# Moments of Happiness

Cherry Orchard Books

# Moments of Happiness

## Alex Dubas

Translated and edited
by Yvonne Howell

BOSTON
2021

Copyright © 2021, Academic Studies Press

ISBN 9781644694961	paperback
ISBN 9781644694978	ePub
ISBN 9781644694985	ebook PDF

On the cover: Photo by Alexander Petrosyan
Cover design by Ivan Grave
Book design by PHi Business Solutions

Published by Cherry Orchard Books, imprint of Academic Studies Press
1577 Beacon Street
Brookline, MA 02446, USA

press@academicstudiespress.com
www.academicstudiespress.com

# Contents

Author's Preface — vii
Translator's Introduction — xi

1. Write Your Own Title — 1
2. Nature is Bigger Than We Are — 19
3. All Happy Families Are Alike, But … — 35
4. Connections — 52
5. Travel as Elixir — 67
6. The Art of Happiness — 83

## Author's Preface

You are in a bookstore. Maybe because it has air conditioning and, on a hot day like today, it's not a bad idea to step inside. Or, on the contrary, it is seriously cold outside and you want to warm up by ducking into a bookstore and flipping through the warm pages of books.

Maybe somebody gifted you this book, or you simply bought it online—either way, now it's in your hands. How did it catch your attention? You liked the word "happiness" in the title? We use that word so often when times are good! So often that a whole plethora of meanings have dissolved into the word, rendering it almost devoid of meaning.

Wait! Don't get the mistaken impression that this is some kind of self-help manual, the kind that teaches you the true meaning of happiness. This book does not contain coaching tips or a step-by-step method that leads you to the "happiness within." Although it's perfectly possible that some readers of this book will indeed experience profound revelation and find answers to long-standing conundrums.

*Moments of Happiness* is likewise not a scientific study of the nature of happiness. That being said, I have a friend at the Bekhterev Institute of Brain Research who has studied the activity of endorphins for decades, and he claims this book serves nicely as a practical primer on how to stimulate those "happiness hormones."

So, the book you are holding in your hands cannot exactly be categorized as "meditation," or "self-help," or "science."

What is it, then?

It is a book about us, by us. A book of our voices.

You will hear these voices. And after you have read a few pages of "moments," you will in fact start to feel happier; the effect is therapeutic. Try it right now. Open up to any page, read any one of these "moments."

In the meantime, I'll tell you about how *Moments of Happiness* was born. One of my jobs is as a radio host. If I count up the total number of hours I have spent *live on air*, it would be the equivalent of two straight years, without sleep. In other words, I have seen and heard a lot, but only once have I broken down and cried in front of the studio microphone.

This is what happened: one evening, our scheduled guest, a famous director, fell through. He got sick, or he got stuck in Moscow's evening traffic, I don't remember which. Our program starts in one minute. I have to think of a new topic. Quickly. I have thirty seconds left . . . what will I talk about to our listeners? This is the peak traffic hour, the moment when about one million listeners in various cities tune in to hear "their" program. . . . I have ten seconds. . . . Was there any actual news today? No, not really . . . three seconds, two, one . . .

*Zdravstvujte. How are you all today?*
*Are we happy?*
*Yes?*
*No?*
*Probably not exactly yes or no.*
*I'm going to start with a short parable to lead us into today's topic:*

> A wanderer came to the edge of a village, hoping to find a place to rest the night. But first he had to walk through a cemetery. The dead were always buried just outside of town, so there was no way to avoid it. He looked around and grew frightened: the gravestones had such strange inscriptions. Other than names, there were only references to "one year and three days," "seven months," "two-and-a-half weeks," "six hours," or "twelve minutes."
> 
> Our wanderer was horrified, and tried to run away, but an old woman stopped him.
> "Why are you fleeing, wanderer?"
> "To get away from a place that kills children!"
> "You have misunderstood. In our parts, we believe that only when we are happy are we really alive. What scared you so badly is not the short time span of these people's existence, it's the time span of their genuine life."

*Let's do this right now, all you listeners out there: I encourage you to call in and describe a moment of life in which you really lived. This next hour will be saturated with happiness.*

I began with a few moments from my life to get the ball rolling.
And then the listeners started to call in with their stories.

Twenty-six-year-old Kira called to describe a moment when she was eight years old, her grandpa was still alive, and they were walking in the woods together collecting mushrooms; and how he tossed her high up and caught her, told her she was his favorite, and the forest world descended around her in orange and gold.

Another caller remembered the sound of a few hecklers right before his performance at an outdoor music festival, and then an extended moment of magic when the entire crowd hushed in response to three *a cappella* voices and a bass drum recreating an old Haitian folk song.

A grown man, Vladimir, called in to describe a February evening in Togliatti, the evening his parents returned home from work and told their two young boys that they were getting a divorce. How the boys talked them out of it.

That was the show that brought tears to my eyes and choked me up on air. Because the stories came out in real time, they were unfiltered reports from the field, about authentic moments of happiness. Only this kind of story can invoke genuine compassion, in the sense of shared feeling. I recognized myself in that little girl with her grandfather and I recognized myself in that little Togliatti boy struggling to keep his family from falling apart.

Listeners shared their "moments" in great abundance. There was so much trust in this! I think it helped that I had asked for stories to be narrated in the present tense, as if they were happening right now. This would allow everyone to feel as if they were reliving the moment of living life: a special effect.

The stories kept coming and coming. We received hundreds of texts. Everyone wanted to share the most important thing.... And, interestingly enough, almost none of these stories were the obvious ones, the "then the nurse brought in our little newborn bundle of joy and laid her in my arms" kind. Usually, they were stories that at first glance would seem insignificant, ephemeral, arbitrary. Taken all together, though, they seemed to make up a collective unconscious, some kind of enchantment.

That is how this collection started. We did two more shows on "moments of happiness," and continued to receive written, email, and text submissions. I posted on Facebook and started

to collect moments through social media. I was amazed by the geography of happiness—we heard from polar settlements and from mountain villages near the Black Sea. We heard from Krasno-darsk and Krasno-yarsk, from various New Towns and Bright Meadows, and so forth, from all over Russia, the Volga region, Siberia, and from the diaspora abroad.

    Taking advantage of my contacts, I recorded "moments of happiness" as told by many celebrities. I interviewed the ones whose stories I genuinely wanted to hear: Mikhail Zhvanetsky, Sergei Yursky, Aleksandr Flippenko, Vera Polozkova, the singer Yolka, Albert Filosov, the writer Slava Se, Ingeborga Dapkunaite, Nikolai Tsiskaridze, Vladimir Menshov, Maksim Sukhanov, Evgenii Mironov . . . in short, actors, directors, musicians, television personalities, and two whole astronauts. In this cohort, just like the rest of us, nothing about happiness is obvious. Viktor Sukhorukov, for example, did not recount a brilliant moment in his film career, but talked about an ancient apple tree in his orchard. Vakhtang Kikabidze talked about getting into a fight in a restaurant on top of Mount Mtatsminda in Tbilisi. You'll find some pretty great stories from actors and musicians, especially in chapter six; but not all of them are in that chapter, and not everyone in that chapter is famous.

What else is there to say about this book *Moments of Happiness?*

You can think of it as an historical document that tells the stories of our times, rather than reducing us to a page in Wikipedia that describes "Russia," "in the so-and-so era," during the "such-and-such period." *What about us?* How did we actually feel, and struggle, and love, and *live* against the backdrop of our times? This book is about that.

    However: this book has some peculiar qualities. You cannot read it straight through, from beginning to end. This is a book to dip into, read out loud, move around in, consider in small chunks, in any order. You will start somewhere and read a few "moments." They will remind you of something, and your thoughts will drift to things you yourself have experienced in your life.

Moments of happiness.

## Introduction

*Moments of Happiness* was a bestseller in Russia. But would it translate into other languages and other contexts? Think of this book as more like a card game, or a prompt for spontaneous theater with your friends, or, of course, a great gift book. Think of it as a game which many different players (of all ages, incidentally) can play. The goal, of course, is to derive some happiness (who doesn't need it?) along the way, but there will be other benefits as well. This introduction describes a few of them.

As cultural stereotypes go, "Russians" and "happy" do not usually go together. Of course, we know that the capacity for happiness is a universal human trait, so, naturally, Russians can be happy just like anyone else, but still . . . when Russian culture expresses itself in a way that takes our breath away in the West, it always seems to be on another note: deep, dark, soul-searching, covered in frost, prone to extremes, and so forth. It seems almost heretical to translate a book from Russian that is about happiness. But it's about time.

It turns out that in Russia, as everywhere else, joy can be found in all the usual places (family, friends, accomplishments, food, music, under a starry sky, etc.); and yet, as anthropologists will tell us, different cultures have different patterns of display: what is out in the streets in one society may be confined to the inner courtyards of another, and vice versa. When radio host Alex Dubas simply asked his listeners to call in and share a moment of happiness, *right now, while you are stuck in traffic on the way home*, it seems that his native audience surprised even themselves. Stories poured in, spontaneously, including the listener who emailed:

> Happiness—is hearing about someone else's happiness. I never thought I could cry on a Monday at 4:30 in the afternoon. From happiness.

Who is Alex Dubas? In the original version of *Moments of Happiness*, he inserted two moments of his own. Following his own rules, Dubas recalled his "moment of happiness" in the present tense, as if he were reliving it now:

> The end of August, 2015. Deauville, Normandy. Noon. I'm sitting on small hill, working on my laptop. The screen blocks my view of La Manche, sailboats, and the city of Le Havre. I'm editing this book. Every so often I tear my eyes away from the screen and look into the distance. A deer just ran by. The scent of late summer flowers and grass. At sunset we'll go horseback riding along the shore. What happiness—to read these stories of other people's happiness, only to get distracted by noticing my own!

In the other "moment" the author allowed himself (in chapter four), we see him howling, literally howling like a wolf, at the moon. His public persona is closer to the moon-howler: in person, he is a celebrity, a performer, a man of great appetites, someone who has ceaselessly moved from one kind of creative-entertainment venture to another.

Dubas was born in 1971 in the Soviet city Kuibyshev (which returned to its prerevolutionary name Samara in 1991). When he was in ninth grade, the family moved to Riga, the capital of Latvia (at the time still part of the USSR). He served in the navy for a year as a diver, then transferred to Lviv (Ukraine) to serve as a military journalist. Dubas has been a Latvian citizen since 1991, and lives and works in Moscow—when he is not traveling. Over the past two decades, his professional passions have included hosting a television series in which he took viewers to "the most interesting corners of the world" in search of cultural, natural, and culinary wonders; hosting shows for Silver Rain, a hip radio station that targets younger, wealthier Russians in over one hundred cities; and performing live on stage in a variety of genres. His theatrical restaging of this book, *Kvartirnik* [A get-together at my apartment], is discussed below, as well as at the end of this introduction in the note on emotional and ethnographic responses.

You know from the preface that Dubas's *Moments of Happiness* project was born out of a flash of inspiration in 2015 when, as a radio host, he desperately needed to improvise on air for an hour after a planned celebrity guest failed to materialize. To this day, people who happened to be listening to that radio show describe it as an extraordinary event, in which something genuine and unexpected happened to about one million people at the same time. In a society that is used to trauma, that hour of spontaneous storytelling felt like a collective reckoning—only this time with something deeply positive, even happy! Dubas set out to recapture and extend the magic in various ways: soliciting more stories on social media and

the radio, gathering them into a book, and performing them on stage as *Get-Together at My Apartment*.

The staging worked: reading the stories out loud brings each one back to life, but channeled through someone else's voice. An actor's voice, or it could be your voice. Try it—the experience of "putting yourself in someone else's shoes" in the moment when the person in those shoes feels happy. When you realize "That could have been me!" in the process of channeling someone else's story, the effect is genuinely startling. These "moments of happiness" happened to people thousands of miles away, whose culture, language, and surroundings are so different! And yet so many of them strike us in a way that is utterly familiar, and somehow surprising for that reason. The young woman who caught the look of undisguised approval and pride on the face of her mother, who was usually so critical (chapter three). The fun of arriving in a big city to visit a friend who lives downtown—and opening the hatch to his attic apartment only to discover that there's a party on the roof! (chapter one) The rush of completing a difficult, even dangerous, hike through the mountains; or realizing that in an ordinary moment you have the power to acknowledge your own happiness. As one of these stories puts it, "Happiness is discovering a book or a film that seems . . . as if it's about me" (chapter six).

It's like a card game. You flip open the book and read: "A moment later she brings in fresh, homemade buns filled with black currant jam, still warm from the oven; she kneaded that dough three times last night. With a glass of milk" (chapter one). How ordinary, almost a cliché. Certainly it's not all about the black currant jam; in someone else's world, it could be chocolate chips or dulce de leche. At the same time, the narrator tells us, she is watching a Disney cartoon for the very first time; prior to 1989, Soviet TV did not broadcast Western fare. In that moment, her childhood horizon has suddenly expanded beyond belief—the novelty of American-style animation and character was profound—but, at the same time, there's the warm taste of Grandma's baking. How often do we associate a mind-blowing experience (of new music, a new perspective, a new friendship) with the food or drink we had at the same time? In fact, what if the simple, separate components of each "moment" described in this book were inscribed on a deck of cards? It would be possible to deal an enormous variety of hands, each of which, as in real life, probably contain the match-ups that spark our happiness. With a bit of practice, attention, and luck, we get better at noticing the possibilities we hold in our hands.

This book works in the opposite way of the sorts of posts on social media which have now been labeled a mental health hazard. *I know that you know that I know* that being exposed to endless images of other people's happiness on the internet makes us feel inadequately blissful—and less happy as a result. Instead, this book collects moments of happiness that remind you of your own. Or perhaps some of these stories remind you of an older relative or friend. Regift them.

In Dubas's original version of *Moments of Happiness*, the stories are listed from 1/ to 947/, without any guiding principle of organization. Nothing connects one story with the ones that follow it or precede it, other than the fact that our perceptions of happiness are immeasurably diverse and unpredictable. This edition abandons the numbering, but applies a light hand of organization. We hope that readers will enjoy figuring out for themselves what themes shine through in the six chapters, and we leave it to our readers to decide how they want to title—or re-title—the chapters.

Finally, we have included photographs by the contemporary St. Petersburg photographer Alexander Petrosyan. Like many of the "moments" in the book, Petrosyan's images capture happiness tinged with something else—an awareness of chance and impermanence, the tension between fleeting moments and lasting memories.

<center>***</center>

## ABOUT THE PHOTOGRAPHER

Alexander Petrosyan is a professional photographer based in St. Petersburg, Russia. He has won multiple awards for his original and outstanding work. We are honored to showcase a few of his Petersburg images in this edition of Dubas's book. Petrosyan's artistic lens captures *moments of life*. He is fascinated by the instant—which can contain contradictory elements of beauty and the grotesque, the mystical and the ordinary. Yet in each "moment of life" that Petrosyan records for us, we discover one of the many tonalities of happiness, ranging from the contemplative and worshipful to the silly and boisterous. For more of Petrosyan's photographs, visit his website at http://aleksandrpetrosyan.com/en/.

## ABOUT THE NAMES

Many people sent in their "moments of happiness" anonymously. Where people signed their names, we have included their first names in this edition. In the case of well-known actors, journalists, and musicians that Dubas interviewed for this book, we include the full name and a reference note.

## ON EMOTIONAL (VERSUS) ETHNOGRAPHIC READINGS

The legendary Russian linguist Roman Jakobson (émigré and professor at Harvard) thought about what the study of poetry and prose can tell us about different types of aphasia (loss of speech, memory disorders in language). To understand why patients lose their ability to "find their words" in different ways, he described the difference between what literary scholars call *metaphoric* and *metonymic* thinking. We can do the same in order to think about why the impact of sharing these "moments of happiness" out loud, as part of a social or theatrical performance, is different than reading them silently, to yourself.

As Jakobson pointed out, when we use metaphors the crucial element of meaning is created along what he called the "axis of similarity." If you say your *love* is like a *rose*, we are jolted into seeing the unexpected similarity between those two things, and the power of communication is a function of what meaning is created when two things—love and rose—are brought together in similarity.

A metonym, on the other hand, creates meaning along the "axis of contiguity." The White House is not a metaphor for the president: it's kind of a spatial extension of his body. So, "The White House announced today . . ." or "The sail [standing for "boat"] disappeared on the horizon . . ." are figures of speech that work because we recognize that one element stands for another.

When these moments of happiness are voiced in front of an audience, it's the metaphorical impulse that matters. You think "That could have been me!" or "That's *so similar* to my experience, something I've felt in a different place, with different props, but that story is mine, except in a parallel universe." This experience "along the axis of similarity" is mostly emotional.

By contrast, when we read these moments silently, one after another, our minds start to run along the "axis of contiguity." We find ourselves thinking about how the reading of one

moment, by virtue of their proximity, affects my reading of the one that happens to come next. That proximity brings out contrasts one would not have seen otherwise. Or perhaps the relationship between one story and the next invokes other patterns in the mind. This experience "along the axis of contiguity" seems ethnographic. Taken together, as Dubas notes in his preface, these stories can be understood as a record of what ordinary Russians were actually thinking and feeling during a period of historical change—from end of the old Soviet Union to the post-Soviet era. In this book, that change is mostly recorded as an unprecedented shift towards acknowledging one's right to—and delight in—all kinds of private, personal, idiosyncratic, individual moments of happiness. The state is nowhere to be seen.

## FOR TEACHERS AND DISCUSSION GROUPS

"Either way, you're holding this book in your hands. . . ." Now what? This collection of moments lends itself to a variety of playful (or instructive) exercises in which students or participants can select various categories through which to read the moments. You might ask readers to rate the moments according to a scale of happiness—from "Highly Individualistic" to "Acknowledging the Power of the Collective Good," for example. Alternatively, you could categorize the moments in terms of happiness that bursts out of newness and discovery to the happiness of returning home, and everything in between. One might ask readers to invent their own system for classifying the tonalities of happiness they find in these stories—from bittersweet to giddy, for instance. What do we call the kind of happiness that flares briefly within a dark story?

As Alex Dubas says in the preface, this is not a scientific manual or a self-help book about happiness. This is a book that we hope readers will make their own, for the sake of their own and others' happiness.

# Chapter One
# Write Your Own Title

*In which a lot happens. It turns out that simply hearing about other people's happiness makes us happy. Experts tell us that being fully, completely* **present** *in the moment, leaving the past and the future outside, automatically creates a moment of happiness. We generally associate happiness with a feeling of intense belonging and solidarity with others. It turns out we also find great happiness in moments of perfect solitude. Collect these moments: when your happiness is complete in others, and when you feel complete within, alone.*

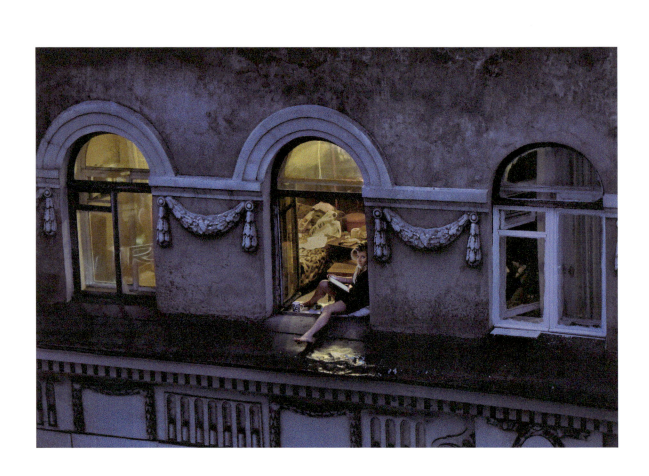

January 15, 2013. I am listening to your radio show *Silver Rain* as I write this. The voices on air are describing their moments of happiness. I am waiting for my students to show up, but they call and say they will be fifteen minutes late. And I am happy to have fifteen extra minutes to experience so many different types of happiness.

I am twelve years old, standing before the cake that Grandma has baked in honor of my name day. She has baked a cake for each of my birthdays—but never one as marvelous as this one! Our entire family sits around the table: Mom, Dad, my aunt and uncle, my sisters, Grandma and Granddad, and my great-grandmother, who is now ninety-three years old! I glance around the table, take a big breath, and blow out the candles, wishing that everything will be good! Of course I'm happy—a twelve-year-old with my whole life ahead of me, surrounded by my nearest and dearest. Then life goes on, and our loved ones leave this world, unfortunately. But these moments stay in our memory forever.

    Thank you for giving me the opportunity to relive them.

—*Anastasia*

My God! Who are all you people, whose stories bring me to tears. … I mean, seriously, thank you. I don't have any happiness, but reading these stories, I'm happy for others. Thanks.

1993. Everything in my life is perfect. I am watching *The Cranes Are Flying* and crying, because how can one not cry when rewatching this classic romance that takes place during World War II? Meanwhile, my own beloved lies next to me, sleeping. My sobbing actually wakes him up: "Why are you crying?" I kiss his eyes and face and sob that no war will ever part us, that we will not be separated: "I love you so much!" Kostya, I will always remember you!

    He was killed a year and a half later.

August 2008. At five o'clock in the morning, my friend and I drive out of Moscow towards Yeysk. The road is terrible, the entire route is under repair, and the heat is hellish. At some point we finally leave the main road. At that moment, a feeling of euphoria overtakes me. By now,

it's almost dusk, and the sun is rolling down behind the horizon, coloring the endless fields of sunflowers purple. Not that the heat gives up. But we've finally reached our destination. Yeysk greets us with not-very-friendly cafes, all of which are full. My friend, on the other hand, happens to have a bottle of tequila packed away. We grab a couple of cups and head for the beach. Now it's completely dark, and a barely discernable breeze blows off the sea. A wave of emotion washes over me, as exhaustion is replaced by boundless happiness.

*—Alexander*

> The road trip from Moscow to Yeysk is roughly the same distance (about 775 miles) as driving from New York City to Savannah, Georgia. The route tracks directly south, skirting the eastern border of Ukraine to arrive at a spit of land jutting into the Azov Sea. Yeysk is one of the most popular seaside resort towns in the area. Our happy road trippers have arrived at a spot which, in the ensuing decade, has become the focus of enormous geopolitical tension. The Azov Sea is connected to the Black Sea (and from there, the rest of the world) by the narrow Kerch Strait, a choke point which Russia is determined to control. Since 2018, mainland Russia has been connected to the peninsula of Crimea by the Kerch Bridge.

It's June 1989. I've signed up as a counsellor after my second year of university, at one of what are still called Young Pioneer camps. We've scheduled a soccer match between the counsellors and the pioneers. I used to play soccer, and now I manage to pull off the most beautiful goal of my life, flying through the air and heading the ball. I get a big round of applause and looks of amazement. For some reason, at the time I thought that it was a moment of happiness.

*—Dmitri*

> Any roster of "Soviet things to be nostalgic about" includes the state-organized and state-sponsored pioneer camps, which millions of children attended from the 1920s onwards. The camps were located in some of the vast country's most beautiful natural areas, and most people remember the outdoor exercise, childhood friendships, and "simple pleasures" that camp life provided.

For some reason I often return to this day, even though it would seem that nothing much in particular happened. It's the year 2000, I am seventeen. September. I am in Dubai, staying at a small hotel on the seashore. I get up at ten o'clock, get washed, and try to make it down in time for breakfast. Then I go to the beach and lie there for the whole day, completely alone. I'm reading, listening to my earbuds, napping, watching the ocean. In the evening, friends arrive, and they show me this amazing city.

—*Masha*

July 7, 2013. I am standing on stage at the awards ceremony for clubs participating in the international Exotic Automobiles car show. My fellow club members, my friends, are with me. Literally two seconds after the winners are announced, the tension breaks into wild screams of excitement and joy. After that I can remember only the weight of the cube in my hands, which I hand over to my friend, because I don't have the strength to hold it up. This means that everything we did for all those long years wasn't for nothing. Miracles happen.

    The feeling of happiness that comes with a much-anticipated trophy is so total that it's hard to stay steady on your legs and your eyes fill with tears. It's a feeling of happiness that you can barely believe is real.

July 1973. I am nine years old. My mom and I arrive on the earliest train to Leningrad. The nearly endless days of the Arctic summer mean that at five in the morning the sun is already high. That is incredible in and of itself. We walk out onto an absolutely empty Nevsky Prospect,

as if the whole avenue were just there for us. Somewhere we buy a pineapple (in those Soviet times!) and eat the whole thing in the nearest café. I am ready to die of happiness.

*—Irina*

July 1993. I am five years old. We live in the contaminated zone. Grandma works for the station that monitors levels of radioactivity around Chernobyl. During her lunch break she takes me to an ice-cream shop, and we bring a big jar of homemade cherry preserves with us. We are walking towards the café, thinking about how we're going to add these cherries to our ice cream.

An orange October day, 2011. I am late for work downtown, walking as fast as I can, hoping to catch the green light at the next major crossing. But it's red. It won't change anytime soon; some kind of bigwig with a long procession of cars is making his way through, stopping all traffic. As I stand there, I realize what a magically sunny day it is, with a bright blue sky and crystal clear air. Happiness is so simple. Without giving it a second thought, I grab a cup of coffee to go and head off towards the park. …

December 29, 1996. The heavy prison gate closes behind me. I have been waiting, and conjuring up this day in my imagination, for six long years. I see my mom, my dad, and my wife. The frosty December air makes my head spin. I am twenty-one years old. The New Year, and the rest of my life, is ahead of me.

December. A snowy night. Everyone in the house is already asleep. I've just barely managed to finish all of the household chores and I'm finally ready to go upstairs to bed. At that moment I remember that I've left a heap of wet laundry in the bathroom, so I turn back … and see that somebody's already taken it out of the tub and hung it all up.

*—Alina*

Why not *now*? So I just came home for lunch, will have to go back to work later; but right now I'm at home, where everything is cozy and nice, smiles all around; it's warm inside, and my orange cat is installed nearby, broad-faced and judgmental, following my every move with his eyes; so I pour some coffee, stir in the sugar, take a sip, and glance out of the window, taking in the noise of the cars going by, the whiteness of the snow that fell overnight; in fact, opening the window vent just a bit, I take in a breath of sharp, cold air, and watch a steady, unhurried still life of life.

It's one of those moments when sometimes the frantic beat—traffic lights, honking, rushing passersby, crowds—goes quiet, like slow motion in a movie, and that's … good.

A sunny day in May 2008. I'm riding one of our fixed-route taxi minibuses to work, in a terrible mood because of some stuff that just went down, and I'm trying very hard to just listen to my music and not look at any of the other passengers. I look up inadvertently: right across from me is a pregnant young woman gazing out the window and smiling to herself. A jolt of strong, concentrated happiness floods me, like never before.

It's late spring/early summer. Me and my best friend Sasha, both of us super-tall—brawny girls, basically—have just passed a horrendous final exam in physics, and we're now striding—no, *leaping*—down the street, further and further away from school, singing some kind of insane song. People coming in the other direction can't help but smile from ear to ear, seeing this pair of long-limbed idiots loping towards them. The sun is shining; we are utterly happy; we are positive that ahead of us lies a long and amazing life.

*—Alina*

February 1994. We are sitting together on a ninety-foot-high trampoline, at night, with a storm howling all around us. We drink icy champagne out of the bottle and smooch like two puppies with cold noses. We sing and we shout, so loudly that you would think we are the only people in the universe. We climb back down the half-destroyed stairs, gripping the decrepit handrails with our frozen hands. We go along the street towards our dormitory, walking on the tram rails, which are dusted with snow. Somewhere above us the full moon is bouncing, and we try to dance a waltz on the rails. It seems that we're so happy, we don't even feel the cold. …

August 2005. Three hours ago, I got off the train at Moscow Station in St. Petersburg. It was my first time traveling by train, and my first time traveling to another city alone. I am nineteen. My friend met me at the station and took me back to his place, a shared space on the very top floor of one of those old communal apartment buildings on Rubenstein Street. So now I've taken a shower, and I walk into my room and open the window. It looks out onto the roof of the veranda of the neighbor's apartment one story below us. And there's a red sofa on that roof. I climb over the windowsill, step down onto their roof, settle into their sofa, and open a beer. The sun is setting. Light is glinting off the cupola of St. Isaac's Cathedral in the distance. Somebody is playing the trumpet. Down below, on the wall of the building across the street, next to a bakery, a piece of graffiti says: "Another World Exists!" I take another deep breath of that hot St. Petersburg summer air and understand … that I am happy.

*-—Nastia*

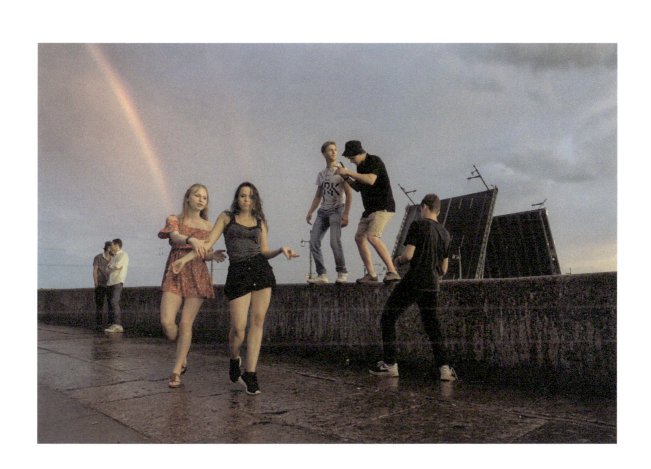

August 2002. I am on vacation at the Black Sea. We go out clubbing on the boardwalk. Somehow my friends have disappeared, so I am surrounded by strangers. Suddenly it starts to rain extremely hard. There are not many covered places along the boardwalk, so I rush to an overhang along with a lot of other unknown people. It's pitch-dark and hard to see the person next to you. One tall guy, who is craning his head over our compact mass of bodies, says into the silence: "Just like riding on public transport." Everyone cracks up and the mass relaxes. Someone passes around a bottle of wine; my friends reappear; … and I remember standing there, laughing and joking along with everyone else, and feeling happy.

 Happiness? One time, my girlfriend and I went out to the dacha and steamed ourselves in the outdoor *banya* [sauna] at night; and then, still completely naked, I went into the neighbor's garden to pick peapods. It was wonderful!

<div align="right">—*Yuri*</div>

December 2006. I am twenty years old. It's my first real job. I arrived before the boss, earlier than anyone. I used the machine to make myself a cappuccino, and walked through the empty room smelling of new furniture. I drank my coffee, twirled around in the office chair. How wonderful, how much lies ahead for me! The irony is that now I hate this company, I hate this job, and I hate the coffee.

Karelia, near Finland. A cold summer in 2003. We are sitting in the bow of a small recreational boat. I still don't suspect that she will be my future wife … and then my future former wife. We are dangling our legs in the water and drinking champagne out of tin cups. It seems as though life is just beginning and ahead of us lies nothing but joy. I am definitely happy. …

<div align="right">—*Andrei*</div>

I often think about these moments, which I characterize as those times when you could die without regrets, leaving life in an instant of complete, unclouded happiness. I have such moments. Here is one that comes to me right now:

> I wake up at night from a bad dream. I wake up and feel the warmth of my husband's sleeping body on my back, and I see my cat sleeping right next to my pillow. I press my whole body tighter against my husband and hear his calming breath. I push my arm under my cat's furry torso and drag her (she gives out a sleepy, almost dutiful purr) to my chest. I am now as if in a cocoon, between the two most beloved creatures in my world, and I am so happy!

December 24, 2007, the day before I go into the army for a year. I'm standing at edge of the opening in our Mi-8 helicopter at an altitude of 4000 meters, about to jump. It's my sixty-eighth time with a parachute.

August 3, 2004. I've been battling this disease for nine months, living from chemo to chemo, and I have long since come to terms with the possibility of death. At the moment, I am in the sterile room in which I have been living for almost two weeks; yesterday, they finished the operation, gave me he highest possible dose of chemo, and today they transplanted stem cells. The doctors also want to do a tomography—and are asking me whether I have the strength walk to the X-ray ward or if I need a wheelchair. Of course I'll try to walk! I am moving down the corridor, with a double mask on, holding onto the stand with the two remaining IV drips attached to it. All by myself! The sight of the corridor, the other faces, and my movement produces a kind of euphoria. I feel like I'm swimming in an ocean of sensations.

Two days later the doctor comes by my room again, and her smile is almost bursting out from under her mask. "Congratulations, you … we … won! Your lungs are clean; all the tumors have disappeared."

I smile and try to think—but I can't. Happiness. Life.

—*Sam*

*… continued*

July 2007. I am madly in love, and the feeling is mutual. But something in my body is not quite right; I have serious concerns that the disease has come back. I hide my fear from my family,

from my beloved, even from the doctors when I go for a scheduled checkup, and for the two days afterwards when waiting for the results. I'm with my love on Mayakovsky Square, in an eyeglasses store. I excuse myself, saying I have to take a work call, and go out onto the street. Almost unconsciously, I wander into a courtyard between buildings and dial the number. Secluded, I am ready to hear that I need to be hospitalized, and I don't know how I will tell her without scaring her. … The calm voice of the doctor says, "Serezha, everything looks normal, you have no new symptoms. So the next checkup will be in November." I stand there in shock … until it hits me like a wave: "No new symptoms"!

The happiness is sharp, almost painful. I run back through the streets, laughing, I feel like bumping into strangers and yelling, "Guess what! I'm going to live! And love!" I almost get lost in the maze of courtyards. When I burst back into the store, my beloved understands everything from the look on my face, and we laugh and carry on together.

*—Sam*

August 2011. My husband and I have only been married for one year. We are celebrating his birthday in a tiny hotel outside of Venice. The woman who works in the hotel, who turned out to be from Ukraine, brings us a bottle of champagne and some bread (the hotel kitchen is not open in the middle of the night). I go for a swim in the pool. Afterwards, my husband hugs me close to warm me up, and then we go in and play foosball.

All of this was like a scene out of a lovely movie.

It's been a year since we got the terrible diagnosis: Mom has cancer, fourth stage. We try every possible therapeutic option. The results are up and down. But today, on the 15th of July, 2012, Mom got up and walked through the house by herself! By herself! The look of death in her eyes is gone. I am happy!

Mama died in September of the same year. But I still remember that moment. …

It's almost midnight. The roads are jammed; it seems everyone is out at the last minute trying to buy presents. Better not take the car. Instead, one can wait out the evening in a café, where sipping a fine Georgian Saperavi wine as the curtain falls on the day is particularly delicious. … The couple at the little table nearby is kissing passionately, while from the ancient stone

building next door float the intricate *a cappella* harmonies of a men's choir. You leave this café, finally, to walk along Rustaveli Boulevard, where the traffic has subsided but the fireworks have begun. With the aftertaste of tannins in your mouth, memories of the performance at Rezo Gabriadze Marionette Theater earlier in the evening, and an anticipatory feeling of spring warmth in the air, you hail a taxi; and driving around the whole of illuminated Tbilisi on a holiday, you remember what it means to be happy.

> The miraculous mountain capitol of the Republic of Georgia has cast its magical spell over travelers, visitors, and lifelong inhabitants for centuries. Rezo Gabriadze's unique Marionette Theater is a cultural destination: http://gabriadze.com/o-teatre/. The dark-skinned, pink-fleshed Saperavi grape is native to the region, one of the world's rare *teinturier* (tinting, dyeing) varietals, providing deep color and acidity to wine.

Novosibirsk, 1989. I am five years old. It's morning. Channel One is broadcasting something we've never seen before—Disney cartoons. I sit in front of the TV and Grandma sets up a little blue tray in front of me. A moment later she brings in fresh, homemade buns filled with black currant jam, still warm from the oven; she punched down that dough three times last night. With a glass of milk. Happiness.

*—Anna*

A piece of honey candy is melting in my mouth. My beloved dachshund (named Little Ribbon) is next to me, and the best husband in the world is washing the dishes. We left the big city (Moscow) to live in this village. We are happy here, and now.

*—Lyuda and Kostya, village of Vysokinichi*

January 25, 2012. Eleven in the evening. I am inside an ambulance. The sound of the siren screeching is excruciating. I'm trying to get my mind around the sound having something to do with me. The prognosis is not good. They take me straight to the operating room, surgeons, anesthesia …

January 26, 2012. I open my eyes. This is happiness! Thank you, doctors!

—*City of Orel, Botkin Hospital*

I graduated from college a year ago, but failed the exam to get into law school. I got a job, and spent the whole year studying to retake the exam. I want to be a lawyer, like my father. He graduated from the school I'm trying to get into. The competition is insane because it is considered one of the most prestigious law schools in the country. Then I pass the exam. In the law school building, I see my name on the list of accepted students. I go to the nearest phone booth and call home. Everyone is so happy for me, and my mother asks what she can get me as a present in honor of my successful enrollment. I still don't know, in 1986, that just ahead lies the collapse of the Soviet Union and its laws, the "wild '90s," and a future in which I will barely scrape by—because to be an honest lawyer and to make money are mutually incompatible propositions in the country we're in now; and that I would have been better off becoming a botanist and studying plants under a microscope, far from all these people with their endless problems; and that, despite everything, I will stick with it and help people, and not abandon my chosen profession. I still don't know any of this, so I say to my mother: "I don't need anything! I got in! I'm happy!"

—*Svetlana*

End of the 1990s. Winter. Vacation at Grandma's and Grandpa's place, outside the city. It's a wooden house with carved awnings. The sheets dry in the frost after laundering, and smell like fresh ozone afterwards. The *banya* outdoors smells of eucalyptus, and we use leafy bundles of

oak to slap ourselves ("Harder! Lay it on me again!") before running into the snow and rolling around. Your pores seem to open up to your heart, clean inside and out, and snowflakes barely land on your glowing skin before they evaporate.

Afterwards, sitting on the veranda, we drink hot, sweet, black tea. The hot heel of a loaf of bread that Grandma has just removed from the wood stove is burning my fingers and melting the creamy butter.

*—Ilya*

This moment was preceded by a horrible 2009—fallout from the financial crisis, death of my father and my grandfather, and my partner leaving forever. Right now, October 13, 2010, I am lying in the ultrasound room trying to see my baby, who is only six weeks, so basically just a tiny spot on the screen. I'm smiling, though, because I'm happy. I suddenly realize that I have always been happy, ever since childhood—I had simply forgotten. My daughter was born on my father's birthday.

*—Nadezhda*

Summer 1991. I am ten years old, on vacation with my whole family—Mom, Dad, my little sister. I am toasting my body on one of those smooth, round stones near the beach. The sun is blinding, and I forgot my panama hat, so I stay drowsily asleep, even through the food vendor's "Pies, come get little pies! …" I want one of those pies, but I'm welded to this stone by heat, laziness, and slumber. Next to me, a friend of my parents is sprawled ridiculously across his towel, trying to catch every ray, and even using his fingers to stretch open the bags under his eyes and get a tan there. His age and his concerns are unfathomably remote from mine. Right now, I am simply happy, I don't need anything more.

*—Evgenia*

Lightening just flashed in the distance. It's already very, very dark. We are sitting on a blue bench near the sea, in Jūrmala. It's raining to the left of us, and to the right. My wife, my kids, and I sit there watching the lightning. There is nobody else around. We can hear the raindrops hitting the ground all around us; but right above us—none. That's the moment: sitting with those closest to me in profound darkness, at one with the elements. It was a beautiful moment. It seemed to me that I understood *who* I am, *to whom* I am, and *whose* I am—all those pronouns opened up like metaphors. I understood through the lightning, through the dark clouds, and through what was happening around us. My next song became obvious—it would be about my heroine—my wife—my kids, and about this wide world. Which is dangerous, but not frightening.

—*Intars Busulis*

> Intars Busulis is a Latvian pop singer. He represented Latvia in the 2009 Eurovision Song Contest.

Kazakhstan, in the 1990s. It's summer, vacation, and we're back in the village. I'm sitting with my sister on a bench in front of the house. Grandma is waiting for her cows to come back to the yard. We're waiting for something to do. We sit there and look at the sky. … Not a single cloud. It's hot. Suddenly we hear the roar of a motor, and we see the truck that takes Grandpa to work. Despite the heat, Grandpa walks into the yard in long pants and a shirt, with his white hat, and there's some kind of bundle in his hands. My sister and I rush up to him happily. Grandpa hands us package of folded newspaper filled with strawberries … huge, juicy, the most delicious strawberries ever! It's amazing how little it took back then to make us happy. …

—*Natalia*

November 7, 1986. Leningrad. I am fifteen years old. Over the summer we worked on a collective farm and earned enough money in one month to save for a trip to the big city. We know that there will be fireworks tonight in celebration of October Revolution Day, so we run down to the granite embankment of the Neva near the Winter Palace. As I watch the spectacular fireworks lighting up the sky, some kids set up an amplifier on the street and blast the voice of Zhanna Aguzarova belting out "We Dance the Leningrad Rock 'n' Roll." Everyone is having a blast, dancing in the streets, and I am absolutely happy.

> 1950s-style rockabilly music sung by a girl from Siberia plus the beginnings of *glasnost* equals "Leningrad rock 'n' roll"—just a few years before communism collapses and Leningrad becomes St. Petersburg again. The 1917 Revolution is commemorated on November 7 (new calendar), the day a band of Bolsheviks stormed the Winter Palace (October 25 on the old calendar), overturning the imperial order and leading to the birth of the Soviet Union. In 1986, the happiness in this account is a seemingly uncomplicated mixture of osteoporotic Soviet institutions (collective farms, celebrations of Lenin's coup, etc.) and the emergence of underground bands like Bravo into mainstream culture: http://www.bravogroup.ru/.

Happiness can descend upon you all of a sudden, when your wife leaves for a trip and you walk around the apartment completely naked, helping yourself to jam right out of the jar with a big spoon, and biting off chunks of a baguette to wash it down.

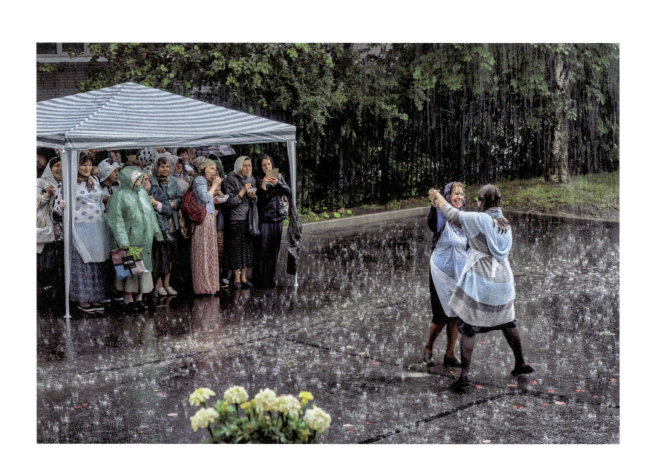

## Chapter Two
## Nature is Bigger Than We Are

*In which so many of us suddenly feel the touch of something beyond us, bigger than us, and even beyond our own species.*

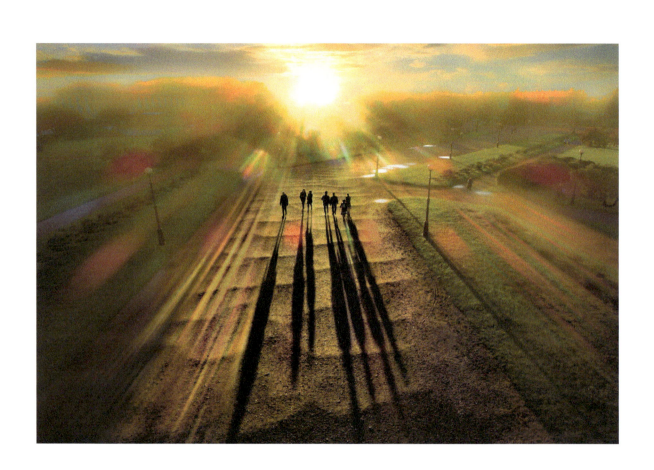

> Citizens of the Soviet Union (1917–1991) were not allowed to travel to foreign countries without special—and rare—permission. But their own country was vast. It spanned eleven time zones and an enormous diversity of landscapes. In the waning decades of Soviet power, internal travel, particularly to the liberating expanses of nature, was very much in vogue. From mountaineering in the formidable Caucasus to tending the garden at one's *dacha* (a small cottage in the countryside), "being in nature" was a national pastime.

I think I was never as happy as I was in the summer of 1995, in those first few minutes.

    I am on vacation, at Grandma's house in the country. I am thirteen years old. For the first time, I am wearing a mask to swim under water. All at once I discover an amazing, completely unknown world! Around me are fish, barnacles, seaweed, and crabs—which I catch. I'm a little bit afraid, carefully reaching down to touch their pinchers. And the silence! That's what astounds me about being under water—the absence of any sound. Now I am a professional diver. I dive into the depths of seas and oceans all over the world. But that first encounter with the underwater world … the magic of that encounter has stayed with me forever.

*—Denis*

Summer of 1989. I am seven years old, staying for the vacation with my relatives in a little town in the Perm region. Gentle sunshine, the suggestion of a breeze, the intoxicating smell of freshly mown meadow grasses and flowers. My cousins and I are playing outside. A cloud appears out of nowhere and we are caught in a terrific downpour. Somehow, the sun is still shining at the same time. We all rush towards a water spout at the end of a walkway constructed out of pine slats. We wash our feet one by one and then run onto the porch which encircles the house. Tearing barefoot round and round the house, soaked to the skin, flinging drops of water up towards the sun. An enormous rainbow crosses the entire sky above our heads. It's hard to imagine anybody happier than us in that moment.

*—Irina*

Summer of 1983. One of those fresh air and wellness camps for kids, outside the city. Andrushka and I have already finished lunch, so we're lurking outside the cafeteria. As soon as the last person leaves, we fly back in and grab all the bread left in the baskets—as much as we can possibly carry. We run straight to a field where two bull calves on tethers have been left to graze. One of them is white with black spots, the other is brown. Our little Beefies! We call out to them from a distance, and brown Beefy abruptly moos and starts to stomp over towards us. He recognizes us!

We feed the bull calves our leftover dining hall bread, pat their big broad heads, and slap their fat little flanks. Our Beefies happily shove their prickly lips into our palms, then lift up their sunbaked heads and slowly chew, letting their saliva drip. Warm smell of cows and clover. Buzzing flies. Happiness.

2005. Altai mountains. My first serious alpine excursion. It was an incredibly difficult day, with boulders, loose rock, and intense heat. … We made it to the highest point of our trail. From there, you can touch the clouds, which stretch across the sky for hundreds of kilometers around, while below you see a mother-of-pearl valley, a lake between the mountains. In short, you hold the whole world in your hands—and I am happy in that world. Happiness.

—*Sasha*

Summer 2010, August. A mountain in the Northern Caucasus. Our group of climbers (there were only four of us) will have to spend the night out in the cold. We don't have a tent, or a burner, and barely any food. For half the day it poured with rain and we were stuck in the storm; now we are soaked through and shivering. We slump against a wall all night, hoping to make the final push to the peak the next day. How I long for morning to come! It's horribly cold, around zero degrees Celsius. We don't have anything dry to wear, so I just sit and stare at the enormous star-covered sky and wait for dawn. …

When it started to get light and I realized that we were about to go further … I was happy that we had lived through that night.

In September 2011 I purposely packed a tripod along with my camera for a camping trip on the Kolsky Peninsula. My dad made fun of me because I was so sure that I would see polar lights. I'd read somewhere that there was supposed to be a major sun storm on September 20 (sun storms always produce polar lights). "But there are no polar lights in September!" my dad insisted. My happiness was complete when on the night between the 20th into the 21st, I crawled out of my tent and saw a gigantic green curtain of polar lights right over my head—as if the entire cosmos was winking at me at that moment.

It's one of those summer days which on the Ukrainian steppe lasts for an eternity. I am sitting with my brother in the tall dry grasses, and neither of us has said a word for at least twenty minutes. There's nowhere to hurry, nothing to worry about. My brother looks at me and smiles. At that moment I am filled with a happiness that is both eternal and tangible, like the hot, dry wind.

—*Egor*

I arrived at the horse stables in June 2004. I had been trying for a month now to get my horse back on his feet after a terrible injury.

But on this particular day, for the first time, he stood up and took a step. We've won! He's going to make it. I'm so happy!

1980, summer. Today I *must* get back on my feet. Since my fall on the glacier, the pain in my back shackles my every move and blurs my mind. … I take my first cautious, torturous, little steps … and I'm wracked by the thought, "Could this really be forever?"

I make it to the door, and immediately beyond the door lies the sparkling diamond-edged world of mountaintops under azure sky, breezes saturated with the scent of pine, and the clatter of striped squirrels scrambling through the tree tops.

I have never seen such magnificent mountains in my life! I have never breathed in air this taffy-sweet! It's coming through to me now—*I am alive!* You understand the meaning of those simple words only after you've gotten your first glimpse of the "other side."

*—Igor*

I was just happy a few hours ago.

Faith, for me, is something inside, and I am ashamed to say that I very rarely go to church. But it's like this for everyone: when things are really bad, when you don't know how to go on, your legs just take you there.

A few weeks ago, listening to me and my woes, a friend of mine said, "Go to Mother Mary; she will lighten your load … really." I took a long time deciding, but today I got up and went straight to the monastery. As soon as I got there, I realized that something unusual was going on. After that, everything happened at once: I discovered that today is the Madonna's birthday (again, to my shame, I didn't even know that when I decided to come today); then I found out that the patriarch himself was about to arrive. I stood there for a few hours, thinking to myself and waiting—although I'm not sure for what. The Patriarch arrived, making his way through a living corridor of worshippers, and I saw him for the first time—literally two feet away from me! He turned and made the sign of the cross over me. … My legs went weak from the unexpectedness of it all, the string of serendipities, and I felt something very precise: "Everything is going to be alright."

I am going home now. … It's November, cold, but my soul is warmed … and tears are streaming down my face. I don't even try to stop them because today I am definitely happy.

Morning, in early January 2009. I wake up from a beautiful dream about a stork on a cliff. The cliff is in the air and the stork's nest is made out of bright, juicy grass. The stork's legs are bright pink. The dream is filled with confidence, and love. I wake up with a smile. A ray of winter sunshine warms my cheek. I am happy, I'm happy right now—and because I know that I will soon meet my future husband. Which in fact happened a few days after I had that dream.

*—Marianna*

December 1, 1997. My son is six years old. We're getting ready for kindergarten. He asks me when the beginning of winter is. I say that today is the first day of winter, that it has just begun.

"Then where's the snow?" he asks

"It's not for me to command," I say. "God decides."

"I'm going to ask God for snow, okay?"

As I was putting on my coat, I saw my son in the dark hallway near the front door, hands clasped and pushed against his face. I don't know where he found out that this is how you are supposed to talk to God. He was whispering something, and I had to wait until he was finished before we could go.

Later in the afternoon, at work, I glanced out of the window and saw snow. At first it was just a few shy flakes that melted before they hit the ground. But it was snow, alright—the snow my little boy had negotiated with God Himself.

That evening, his eyes burning with happiness, my son yelled joyfully about the first snow, and I was unbelievably happy for his happiness. It sent a shudder up my spine.

—*Inessa*

A very hot day in July 2006. I am crawling through a thick swampy forest near the Volga, training to do fieldwork, making my way towards a bluff over the river, looking for songbirds. I'm an ornithologist. I finally make it out of the dense growth of trees, only to discover that somewhere back there I dropped my camera.

What are the chances I will find a camera in that forest?

Miracles of miracles, I found it. Then I made it back out to the high bluff of the river, deep wild forest all around, a sea eagle gliding above me, a barge on the water below, and nobody else at all—only tired, happy me.

—*Maria*

1995, December, in the seventh grade. It is minus twenty degrees outside, no wind, no clouds. My father and I went out to hunt on skis, with our dog. For half a day we skied across fields

and dales, past villages, ponds, haystacks. A hare got away from us, but so what? At a certain point, we decided to sit down and rest near the edge of a forest. Looking from the roof of our five-story apartment building, this place is visible just on the horizon. I started to play with our dog: she barks and jumps and grabs my sleeve; I pretend to fall and roll in the snow. … Dad has retrieved our lunch from his backpack— black bread with fatback, Mom's pierogis, and a thermos of hot tea. Dad and I are fans of strong tea on a hunt.

So here we are at the edge of this forest, sitting on the fresh planks of a wooden bench the forester has recently constructed. I think about how lucky I am that our new apartment is on the edge of town, in an interesting place, that I have great buddies with whom I get into new adventures every day (without my parents knowing), that I also got lucky with parents (even if we sometimes argue until we cry), and that we got lucky with the weather (I love frost with sunshine). I think about how nice it is to feel that cup of tea warming my hands, and in fact how totally cool it is that New Year's Eve is just around the corner.

2004. On a highway. Once again, I'm driving 2,500 kilometers to visit the woman of my dreams. To be with her. If only for twenty-four hours. Thoughts, emotions, anticipation. … The undulating road stretches ahead for countless kilometers, straight as a rail. Goran Bregović's crazy Balkan brass is pumping out of the CD player. Suddenly, as I go over the crest of a hill, I notice that the road has split the sky into two totally symmetrical halves. One half of the sky, to the left, is bright blue, sunny, not a cloud. To the right of the road, the sky is completely black, lightning flickering in the distance, and there's a wall of rain.

Music, plus feelings, plus speed, plus some kind of divine geometry. Memorable.

August 1990. I am nineteen, and I am serving in the navy. I still have several more years to go. … I'm standing on the deck of our aircraft carrier. The ship is at anchorage in Sevastopol. My friend and I are sneaking overboard to go swimming. In the distance, you can see the lights of the city, and even hear the music. Somewhere people are dancing and having fun—because, as opposed to us, they are free. I dive into the warm water of the Black Sea. Suddenly, I am glowing all over! It's those tiny microorganisms that fluoresce when they come into contact with something alien; in this case, my entire body. The water goes down for a kilometer beneath me, but I am hovering here on the surface. Hovering, illuminated. I am happy. There

are no material or emotional reasons for it—but I am happy. Here and now, a tiny figure swimming around a huge ship. For some reason, at this moment the strange and inexplicable knowledge came to me: everything will be okay.

*—Aleksei*

A very early morning in 2000. I am on my way home. Home is in one of those homogenous gray apartment blocks in a featureless development for commuters. I round the last corner and get to my building. Right there, on a half-empty lot, shrouded in mist, a herd of horses is grazing. You *could* think, "So what? A few horses." … But against the backdrop of those sterile suburban buildings, the picture seemed surreal. A wave of happiness surged through me, as if all I had to do was push off a little harder from the earth and I would fly. I used to feel that way so much more often—that all I need to do is push off a little harder. …

*—Ilona*

A man-made forest lake, somewhere outside of Zvenigorod. Quiet. A little bridge, under the shade of bird cherry trees that are dropping caterpillars. Yes, somewhere on the far shore they are cutting grass with a gas mower—*zzhh, zzhh*. … Every so often the motor stops, and somebody sneezes.

We cast the first line. None of us even believes in fish anymore—we spent the first half of the summer on the Moscow river and came up totally empty-handed. We bait a second line, and just then my phone rings, and then … f\*\*\*—something is biting! The rod and line simply fly off into the water; we didn't even have time to grab it. I run after it, across the bridge, laughing and chasing along the shore. It's gone—both the fish and the damn line!

We went back to our apartment-headquarters to fetch another rod and line. A guy in a boat sailed by, threw in a hook a few times, but couldn't find our missing line.

Still, the lake is warm, so I sit on the bridge and dangle my feet in the water. A sturgeon leaps out of the water, its silver body twisting in the air. Ripples of water as it plunges back in. ….

No thoughts, just water, sun, water. …

Wait! A nibble. I pull, it seems something's there … and what comes out but the entire rod which originally flew off behind the line with the bait.

After that everyone starting getting a bite. We caught seven sturgeon and threw five of them back—how many sturgeons do you really need? I kept a little bream as well—I love small fish.

My skin smells of river, fish, and sun. …

And my heart remembers: peace, quiet, and freedom.

—*Natasha*

I'm still very young, and my little brother is even younger. It's a very late summer evening and we're at home. Outside, the sky abruptly grows dark, and a ferocious thunderstorm unleashes sheets of rain and streaks of lightening that flash across the violet sky. Mama warms up *ukha*, a clear fish soup made from fish that Dad caught just the day before. We all sit together in the midst of the storm, without turning on the lights, eating in the dark. Every so often my brother and I run to the window to watch the light show, then return to the table to slurp big spoonfuls of aromatic soup.

—*Kristina*

When you approach the store (especially in the evenings), it smells like birch tar.

Smells have an amazing quality. You breathe in. Close your eyes. When you open your eyes, you are of course still the same person in the same place, but your outlook on life has completely changed.

I'm walking along, daydreaming. I have about five different trains of thought at once—anxious, practical, romantic, meditative. It depends, but generally that's the way I am. Either dwelling on yesterday or thinking about tomorrow. Suddenly—hello!—that smell. Birch tar.

I come to. I am—here. A single instant of my life.

We are at Nikolina Mountain. That store. The children are sledding down hills. Laughter rings in the distance. Pine trees. Frosty, transparent air. The smell of birch tar. That once-upon-a-time sensation of a moment that contains eternity. …

Along with my strange and unusual certainty that, in fact, everything is going to be okay.

—*Natalia*

> Archaeologists have found evidence of human use of birch tar since Paleolithic times. Birch tar has powerful antiseptic qualities, and an intriguing scent. It has been used for centuries in soaps, leather conditioning, perfumery. A bar of birch tar soap smells like a winter-green campfire; but once lathered up on your body, it has the opposite effect—wicking away all odors until nothing but ozone cleanliness remains.

I was about ten years old. My brother, sister, and I had just returned from summer camp back to our apartment block. Tired, cranky from the long ride, and dreading the gray school days looming ahead. Mom and Dad are at home to welcome us; and ours is the kind of family that makes a lot of noise, so the neighbors are annoyed. At this moment, Dad pulls out a kitten—a little orange tabby with floppy ears. For some reason my brother and sister have disappeared, so I get to take this little miracle into my hands. It's hard to find words for the emotions that flood me, but it feels like a piercing happiness that I will always remember. It's hard to understand exactly why, but the sensation of holding a tiny kitten provokes so much caring and positive emotion—I'd never felt anything like it before. That year the Olympic Games took place, and the mascot of the Games was the orange tabby Petka. Of course, we named our kitten Petka. …

—*Ekaterina*

Probably many moments of happiness are simply forgotten, but I remember one very precisely. In the summer of 2013, my boyfriend and I are on a tiny Indonesian island, seemingly cut off from the rest of civilization. It's nighttime, and we are lying on the beach. The Southern Cross is shining in the sky above us, and the sea is aglow with phosphorescent plankton. It looks like a fairytale, or a dream. … I ask him, "What are you thinking?" He: "Absolutely nothing, but I'm just so happy. …" That emptying out of all thought, when you become aware of the importance of the moment and all thoughts disappear … that is happiness.

Mongolia, 1977, summer. I am four years old. I am taken on a Sunday picnic in the middle of uninhabited nature with my parents and their friends. While the grown-ups get settled in our spot, I wander off and discover a field full of very large and beautiful flowers. As I run into this field, I have my first terrifying revelation: the day has suddenly turned into night. Butterflies explode into the air. That combination of terror and the happiness of experiencing intense, all-encompassing beauty is rare. It happened again in the same place, but on a different occasion, when we stayed overnight. As I lay under the starlit sky, it was so tremendously bright that I realized the sky is actually no more than a worn umbrella shielding us from an enormous night sun. Again, that sensation of beauty and terror. The grown-ups were pleased with my bold theory, which made me happy.

*—Anton*

1998. Lake Baikal. We turned off our phones and left, first for two weeks, then it stretched out to three. … We were lost in time, and in space. Just she and I. Morning coolness, the scent of cedar, and freedom! I started to understand why people go off to Tibet to become monks. To this day I can feel the lightness, the utter disappearance of anxiety. Those were three weeks of happiness!

Summer 1993. I was on my way back from a month-long biological expedition in Russia's Central Chernozem region. I decided to spend the night in the Galich Mountain nature reserve on the way back. I slept for twenty hours straight and woke up in the middle of the night. A lone cabin in the woods, impenetrable darkness, a terrific downpour, and I stand on the porch

completely alone. I feel good. I feel happy. It's a short-lived kind of happiness; three hours later, I was already wishing for happiness in the company of other people, for civilization, and so forth. Yet to this day, the memory of that moment calms me and brings me peace.

Winter 2000-and-something. For a whole day, we were making our way to this tiny little village in the Carpathians. First we rode the train, then a bus, then for the last five hours we rattled along in a freezing cold, disgustingly dirty, local electric train. Our hands and feet went numb. It was too cold to doze off. We drank whiskey that we tried to bring to room temperature under our armpits, and we played that game where you have to name a city that starts with the last letter of the city the other player's just named. By the time we got to the village, it was night. When we stepped out of the car and looked up, the sky was above our heads. No, not like that. Above our heads was THE SKY. Never in my life have I seen the sky so close, with such an unbelievable number of stars. These stars were low and fantastically bright. And they were falling, slowly cutting through the heavens in a silver line. Snow sparkled on the ground. I was happy. I felt like a small part of something infinitely great.

To define what happiness *is*—that's not easy. To describe what it's like—that's easier. Happiness is something you encounter one-on-one, within yourself. It is always ultimately only yours, beyond the collaboration of others; the moment of happiness is hidden, fragile, and thrilling.

Sometimes, in one of those hidden moments, I am sure I will remember it in the future. Sure enough, I remember flashes of happiness like separate stills taken from life, always only lasting a few minutes, at different times, in almost any situation.

When I was thirteen years old, Dad and I went to the Estonian town of Narva and lived in a forester's hut for a few days. He and I went fishing every day. We had a good time together, just he and I, surrounded by deep forest and the river. It was early autumn and the air over the water was so dense, especially in the mornings, that it carried every sound throughout the whole forest. Narva is far enough north that the sun was already setting much earlier, pouring its last rays across the earth. I mourned the end of summer. I remember how we sailed away from the shore early in the mornings, threw our lines into the water, and I sat in the boat and examined the world around me: the river, keeping life's secrets in its depths, the pines on the shore, which have been standing there silently for hundreds of years, the fish under water, who don't know of the strife and chaos on earth. I felt some kind of happiness then, although I

couldn't define it. That solitude in nature, that moment you can't hold in your hands and look at more closely, but which can be retrieved over and over again in tumultuous times—that moment in the boat, serene and contemplative.

It's the end of summer. I'm a gardener. I would advise you, dear reader, to love, as I do, gardens, vegetable plots, container gardening, parks, orchards, botanical gardens. They have the effect of calming us, harmonizing and detoxifying us, from inside out. Gardening is my godsend. There is a time to cast away stones and a time to gather stones. My garden helps me gather together all the stones I need to last me until the next season.

It's the end of summer, apples are hanging from the trees. We have a beautiful crop this year. My story takes place in the countryside outside of Moscow.

One of my apple trees is very old, and dying. I say to my sister, "Galya, we are not going to cut down anything anymore; let these old apple trees die their own death, branch by branch, leaf by leaf, centimeter by centimeter of their old trunks; let them sink back into the place they came from."

Suddenly I notice that one old branch of the dying tree has "reached over" to the veranda and shoved a water pipe aside. I say, "Bitch! Where do you think you're going? Not enough water where you are? You could've grown out to the side, but no, you had to smash into my gazebo? I'm going to cut you down, you old hag!"

You won't believe me, but by the end of that summer there were fat, juicy red apples hanging from that tree. I even have photographs to prove it! I started taking pictures of the branches, which were heavy with a huge quantity of apples. But that's not the happiness part. The happiness has to do with this: I yell, "Galya! Come here!"

Galya is actually frightened, as I'm standing on a stepladder taking pictures like crazy: in between the apples, little blossoms are covering the branches. That's it! That is happiness! I am witnessing something that has to do with the miraculous. With a miracle! Not a freak of nature, nothing supernatural, not a portend, but with something that seems very, very sacred. I am witnessing the kind of joy that has to do with resurrection. Rebirth, damn it! In other words, when that dying son of a bitch suddenly looks at you with eyes that are still alive, glinting with something new, about-to-be-born, promising hope—this is happiness.

*—Viktor Sukhorukov*

Viktor Sukhorukov appeared in Russian stage, film, and television roles after getting his start in comedy theater in 1974. He has played thugs and menacing bad guys, as well as historical figures like Emperor Paul I. International fame came with his roles in Alexei Balabanov's hugely successful crime films *Brother* (1997) and *Brother 2* (2000).

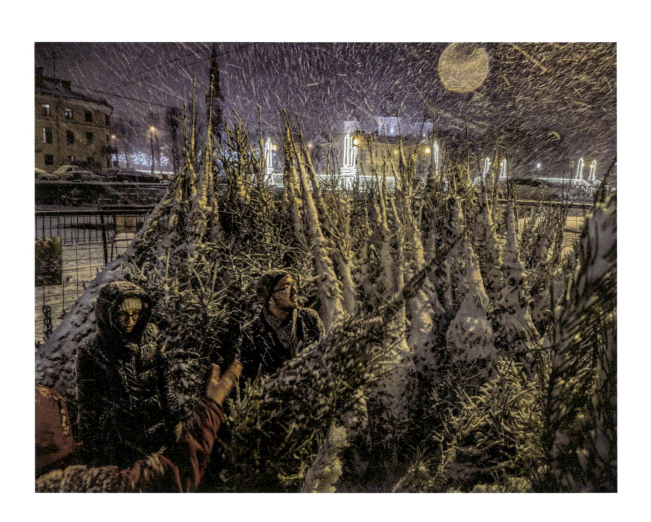

## Chapter Three
## All Happy Families Are Alike, But ...

*In which, repeat after Tolstoy, "All happy families are alike. ..." Stories of birth, fathers and sons, mothers and daughters, grandparents and grandchildren are unique to each of us, yet translate easily across different times and places.*

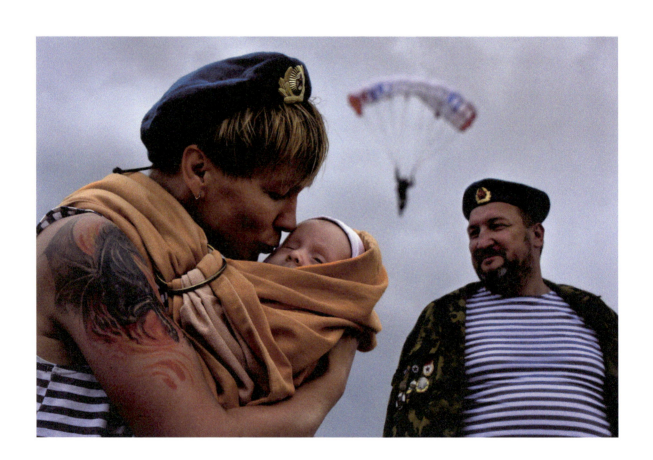

Today. I am at home, asleep, when a phone call wakes me up at twenty to one. I hear my brother-in-law say, "Well, Aunt Natasha, congratulations are in order!" I start to cry, talk to my sister, and cry some more. … They are so calm, as if they had just gone out and bought their Vanya at the store. Whereas I am flooded with tenderness and happiness because Olya, who will always be my little baby sister, has just become—a mother.

—*Natalia*

I really wanted a boy, I was hoping that the baby would be a son. I was on top of the mountain—if you've been to Tbilisi, you'll know that we have a funicular trolley that takes people up and down from the center of town. Mtatsminda Mountain. I was sitting up top, in the restaurant up there. At that moment, they called from the hospital and said, "You have a baby boy!" I went nuts. I must have gone wild from happiness. By the end of it, we'd been beaten up pretty thoroughly by the guys drinking at the table next to us. But I was absolutely happy. I went home. It was summer. I had light trousers on: the right pant leg was red with blood. To this day, I have a scar on my leg from when my son was born.

—*Vakhtang Kikabidze*

> Vakhtang Kikabidze is an iconic Georgian singer, songwriter, actor, and performer. He played the homesick helicopter pilot in the 1977 cult film *Mimino*, at the start of a long career of outstanding performances and international awards. The son of a Georgian princess, he always had the looks, talent, and outsized personality of a beloved celebrity. Mount Mtatsminda, the highest point of elevation in the Georgian capital of Tbilisi, is an unmistakable landmark that draws visitors to its pantheon of tombs (a necropolis of famous writers and rulers), as well as to the amusement park at the peak, complete with Ferris wheel, rollercoaster, and splendid views of the city.

It is a hot day in June, 2013. It's eight o'clock in the evening, and I still haven't finished this long day at work, I still haven't had time to send a text to my wife, telling her how bad I feel for our little dandelion. I can't; we're in business negotiations; the meetings go on and on and don't end.

I get a text from her: "Our little girl [she was only born six months ago] got her shots, and she's bawling her head off." I want to write something back and realize that no words can convey how much I love this little being.

I am happy. It finally hit me that I am actually someone's daddy.

*—Andrei*

Current time. It seems to me that I have never been *happy*, in the sense that everything happens the way it happens, sometimes for the better, sometimes for the worse. But perhaps I'm mistaken, and maybe I've been happy all along. Although my mother is still alive, I lived my whole life without a father … although that doesn't really bother me. They say that he was a good person, the type of person who was wise, would give good advice—you know, like break up fights. … So it's kind of a bummer, really, that he never got to see how I've turned out and how I've done ok. He didn't have that happiness; his life was too short.

*—Dimka*

April 7, 2005. I have just adopted a boy. He is two years old. A friend is driving us home. They warned us that he will cry. He doesn't cry. We arrive at the house. He doesn't cry. I feed him and put him to bed. He isn't crying. He falls asleep. I sit as quiet as a mouse, terrified that he'll wake up and start to cry, and that I won't be able to console him. I start to drift off. I wake up to sniffling, and suddenly: "Mama." I am so happy that I am the one who starts to cry.

*—Natalia*

It is May of 1992. In the city, lilac bushes are blooming, the school year is done, and my parents are ready to send me off for the summer to my grandparents. Because of work, my mother can't take me herself, so I'll have to travel as a minor in care of the train attendant all the way from Moscow to Novorossiysk, which takes more than a day. This particular train is scheduled to arrive very early in the morning. At 4:30am, hunching my shoulders against the cold, I stand in the vestibule at the front of the car, breathing in great whiffs of locomotive steam and that irresistibly acrid tar smoke smell of creosote. Through the windows I see the last fields flying by, and then the train starts to brake as we get to the station. I quickly hop out onto the platform because this stop is only two minutes long. I can see Grandpa hurrying towards me. He is smiling broadly and yelling at the top of his voice, "Run to me, my little kitten! Careful, don't trip!" I run as fast as I can, heart pounding in my chest, until he grabs me, throws me up into the air, and then hugs me tight. "You're finally here, my darling!" His blue-and-white motorcycle is parked behind the station. I put on a helmet and sit in the sidecar. We drive home. There are three months of summer ahead. We will all have breakfasts together outside under the huge walnut tree, and I will read my books out loud to Grandpa; and when August comes, we'll ride the motorcycle out of town to pick fresh corn from the fields.

*—Mari*

Nizhny Novgorod, May 9 of any given year (it doesn't matter), and we're going to the parade with my grandpa. He is wearing his medals; he is mobbed by well-wishers who give him flowers, hug him, thank him … and he is so handsome. The parade always begins with the veterans' procession, and as we walk through the roped-off span of Minin Square everyone applauds. I grip my grandfather's hand; I am crying, I am proud, and I am happy.

*—Svetlana*

December 1986. I am three years old. Today Grandpa is picking me up from nursery school. It's already late in the day, completely dark outside. Big snowdrifts everywhere and more snow glancing through the cold air. Grandpa pulls me home on a sled. I am wrapped up like a

cabbage, only my little nose is sticking out as I lie on my back and look up at the starry sky. It is only this clear when it is extremely cold out. Today the stars are particularly bright. It's good to be here. Nothing bothers me, I just *am*! In front of me is this man's broad, strong back— my grandfather. I feel absolutely safe and secure behind that back; behind that back, nothing can get to me. I am happy.

—*Anastasia*

1992, winter. I am eleven years old; my brother is eight. Today is the most frightening, and subsequently the happiest, evening of our short lives. Mom and Dad call us into the kitchen for a serious talk. They inform us that they are going to get a divorce and live separately. … Then everything becomes a blur, but I remember tears, hugs, and my parents' promise that they won't divorce after all. … In the end, we felt a fleeting happiness, that we had saved our parents and the family. *The Adventures of Shurik* was on TV, my mom started frying up our favorite chicken cutlets. … But alas, it was only a phase, because later on they got divorced after all.

—*Volodia, in Togliatti*

> The un-Russian name of Togliatti has a story: the original town (called Stavropol) disappeared underwater when the Kuibyshev dam and hydroelectric plant was built on the Volga in the 1950s. The city was entirely rebuilt on a different site, where it became the home of the USSR's largest auto manufacturing plant in the 1960s. A joint venture between Fiat and the Soviet government sealed the deal, and the city was renamed in honor of Palmiro Togliatti, the powerful secretary of Italy's postwar Communist Party.

Summer of 1983 or 1982. I live with my parents in one of our military towns, and I'm about five years old. My parents come home with a noisy group of friends, and one of them takes me

aside and gives me a soldier's helmet studded with bullet holes that he says is from the war! I am happy. (As I later found out, that helmet was shot up for target practice at the shooting range.)

*—Igor*

When I was a child, I thought my father was a German spy. I mean, everything just added up: Papa is blond, blue-eyed, and in his toolbox I found a German cross (yeah, that's right, it turned out to be a blade for the kitchen meatgrinder). I shared the news with my mother, and she deduced that I had been secretly watching the addictive Soviet espionage thriller *Seventeen Moments of Spring* after lights-out. What happiness to hear that, no, Papa is not a German spy.

I have a granddaughter, Verochka. She's two and a half years old, and I love her very much. Once we were walking home together from the playground in the winter, and she said, "Let's go somewhere far, far away." I said, "Okay, let's," and suddenly everything changed, like in a fairy tale. It was getting dark, the street lamps had been turned on, and it was snowing heavily. Verochka's little hand was warm in mine. We talked about the Snow Queen, not the one in the Hans Christian Andersen story, but about a kind, beautiful, mysterious snow queen who lives far away in her magical ice palace. It was not at all far to our building, but we managed to discuss gnomes hiding away from the cold, and to admire the gigantic flakes floating through the lamplights. … And then we were at our apartment entrance; our time together had ended. It had been a very simple and very profound moment of happiness.

*—Maria*

January. I am at home alone. My legs suddenly don't want to move; I flop onto the couch. I am holding this little plastic stick, and I see two lines on it. It's the pregnancy test kit I happened to find in the bathroom and decided to try. … Tears are streaming down my face; I have one hand on my stomach, and with the other arm I hold this thing up in front of my face with all my might, but I can't see it through the tears. … I'm a mama! He wanted to make this baby so badly, and I really didn't think it would happen. … I dial his number, but can't get the words

out; I just sob into the phone. I'm imagining my round little belly and him next to me. I feel happiness in every cell of my body.

The baby was never born, and he and I parted ways. But I still remember that moment of happiness.

The day, the year, and the night of the Moscow earthquake.

A few hours ago, I gave birth to a son, the child I prayed for and tried to conceive for seven years. All the other women in the birthing ward are asleep, exhausted.

I am wide awake.

I am absolutely happy: no more "barren fig tree," but "a reason to live!"

I'm not surprised when the bed starts to shake, and the room trembles—the earth is rejoicing along with me.

Today I wired flowers to my mother in Berezinka, the little town in the Perm region where I grew up. The package included a bottle of champagne, a huge bouquet, and a card. Mom called me that evening and cried on the phone with happiness.

"Mom, it's ok, don't cry!"

"But you were right. You haven't gone that far, even though you're far away in Moscow. Mashka, nobody has ever sent me such beautiful flowers, it's … it's just like in the movies!"

"Exactly, Mom, like in the movies, yes."

"I don't even have a vase this big!"

And she kept talking, about the champagne, and about how Varya had already eaten most of the birthday chocolates. I smile and also start to wipe my eyes, glad that over one thousand kilometers away my mother stands in the middle of her living room with a "Love from your little rascal" card in her hands. I am happy that I have made her so happy.

Fall 1988, I am five years old. Papa is still alive, huge, bearded, and we are walking together, holding hands. We are eating big slices of black bread with homemade raspberry jam. Walking down the street, raspberry jam on bread, treetops reaching straight up to the sky, and it seems that Dad does, too, so life is basically just happiness. …

Early June 2006. We are in Sevastopol, Crimea. Our two weeks at the beach have flown by like in the movies, a truly magical family vacation. Now we are sitting in McDonalds. Two-year-old Alenka is taking fries from Mishka's box, and nobody has a problem with that. I watch her and nearly cry from happiness—this is the child who just three months ago was covered with bloody scabs from allergic reactions to everything. This is the child for whom even vegetables were off-limits. This is the child who, for most of her two years, subsisted on nothing but buckwheat porridge and boiled potatoes because anything else would set off an acute reaction, which no medicine could control. And now I sit here and watch as she calmly eats French fries, nibbles on pizza, drinks juice, and basically eats whatever she wants—and NOTHING WILL HAPPEN. Her cheeks don't even flush. I do not have any explanations for how all this could happen in just two weeks by the sea. It was a miracle!

July 1999. A wild thunderstorm raged all night. Now I am driving home with tears in my eyes, through streets that are already drying in a sparkling clean city. My son was born last night. I spent the night in the hospital and saw him for the first time, so small and funny, with a tiny little face that doesn't look like any of us. So dear and defenseless—my son.

December 31. I am thirteen years old. Even on New Year's Eve—in fact, especially on a big holiday! —there is no way I want to miss riding practice at the stable.

There are seven horses and seven of us who want to ride, so it works out perfectly; except at the last minute my dad calls and says that we have to drive out to the country to celebrate part of the day with my great-grandmother. I feel like I'm being callous, but that doesn't stop me from sobbing and begging, "Can't you go without me?" No. They console me by saying I can go to the stable later, when we get back, to be with my favorite horse.

Chervonka is small and fat, a dapple gray, and because she is in foal you can't even saddle her. She has long gray eyelashes. She's very calm, but also kind of mean. Now she and I are alone in the riding hall, after practice; I'm just walking her. The trainer went back to the stables to warm up. Outside, heavy snow flakes are falling, and New Year's Eve night is gearing up. I lie on my horse's big broad back and feel her every movement with my whole body. I'm crying because I'm so happy.

Right now I'm in our courtyard, and it's 1980. All anybody can talk about is the upcoming Olympics. I'm about five years old, and I live in a communal apartment with my older brother Sergei and my parents in Nizhny Novgorod (which was then still called Gorky). I don't remember anything about my childhood except that next to our building there were garages, and we played on top of them and behind them. That was the territory of our childhood adventures. So here's my moment of happiness: I am standing there, and in front of me is new red bicycle. The front fender is made of shiny plastic, like on a German motorcycle. The tires look fat and reliable, so I am ready to ride! There's not much that compares with this kind of happiness.

—*Vladimir Kristovsky*

> Vladimir Kristovsky is the lead singer and rhythm guitarist of the pop-rock bank Uma2rman. @uma2rmanband.

An Austrian colleague arrived with a gift of sweets in a brightly colored box that comes with a soft toy—something like a cute troll, hairy and lilac blue, with one thoughtful yellow eye and a wide smile that stretches almost around the whole toy. When you pet it, it burbles something in German and laughs. As far as the sweets, it was pretty obvious that we should treat the nurses (they need all the sweetness they can get in their not-easy lives), but it was not so clear what to do with the toy. So it went with us as we started back across Moscow during the usual horrendous rush hour. A red Toyota moved along parallel with our car.

In the driver's seat, a woman with long blond hair was desperately waving her arm around, and in the back seat, no less agitated, a little girl, about five or six years old, was waving both arms and legs, screaming. This battle of wills went on for ten minutes without stopping—the young one stood on principle and had no intention of giving up.

Periodically, we'd inch forward a bit, and then their lane would catch up and move ahead of us, but for the most part the picture remained the same. I tried to tame the enraged child by making funny faces at her, but that did not work, probably because I am a grown-up. Suddenly, I remembered the toy and pressed it against our passenger window. At first,

the girl was so surprised, her mouth just stayed open, with no scream. Then her whole world narrowed down to just this strange lilac creature, and she stopped noticing anything else.

The sudden silence apparently startled her mother, who twisted around and looked in my direction. We slowed to a halt, flashing the emergency lights. I rolled down my window and reached out with the thing. The Toyota crept up carefully, the back window went down, and, looking uncertain, the little girl cautiously took it. Amazingly, in the endless line of creeping traffic behind us, not a single asshole honked. I could read "Thank you" on the lips of the mother, while the Toyota inched ahead, her emergency lights still flashing.

June 2013. You are sitting on the floor completely naked. Your eyes are sparkling with happiness, and you are laughing as hard as you can. Yes, you did this yourself. Without my help. You wiggled and grunted and drooled, but you crawled to that toy box all by yourself. Your first steps, my little one. How I wish you could remember this moment and always feel this kind of happiness when you reach your goals.

*—Katya*

2001. July. I'm a summer camp counsellor for a group of kids from the Kazan orphanage. The session is over, and my campers are about to leave to go back "home." Three-year-old Maksim knocks on the window and yells "Goodbye, Daddy!" I run after the bus.

*—Rinat*

1992, summer, early morning. It's about eight in the morning. I pretend that I'm asleep. I can hear my dad quietly gathering our fishing tackle while I continue to slumber, but I know that in a moment he'll come over and shake me awake: "Time to get up." This happens almost every weekend. We gather our things and set off for Izmailovsky Park, a vast area of cultivated forest and reservoirs, where we will catch fish. My dad has a lot of fishing gear, so he lays it all out while smoking one of his Java brand cigarettes. His mustache is stained a bit yellow.

Meanwhile, I throw in my little hook and catch gobies, feeling thrilled about every nibble I get. My dad looks at me with total approval and says, "Fantastic," 'Great," "Way to go." Not everything in life goes smoothly, as they say—lots of things go wrong, and my dad is no longer with us. But I have remembered those times with him for my entire life.

*—Ivan*

End of the 1980s. We are celebrating the birthday of one of our sons in our new apartment. They are all here: the oldest one—our ironic schoolboy; the middle one—a live wire; the youngest—sweet and trusting. For them, death and evil do not yet exist.

"Little fish, little fish, do you think I'll get my wish?"

Children's shrieks fill the room to the ceiling, and I stand in the middle of this commotion. … A thought sears my mind: "This kind of happiness will never repeat itself." Children are a kind of happiness that passes and moves on.

*—Elena*

On August 10, 1990, I am thirty-six. I am giving birth to a child. I have wanted this for so long. I dreamed of having a little girl: how I would braid her hair and go for walks with her, first pushing her in a stroller, then holding her hand, then walking by her side, looking up at her. (For some reason I always wanted my daughter to be taller than I am, which turned out to be the case.) I was sure we would be very close. As it happens, I never found a husband, but I got the long-awaited child. For the entire duration of the pregnancy, everyone, doctors as well as the all-knowing grannies in the courtyard, prognosticated a boy. "If it's a boy, then it's a boy," I sighed.

Now it is August 10, 1990, 9:30 in the evening. Exhausted, hearing the baby's first cry, I say to the doctor, "Well, what?"

"What what?" answers the doctor. "It's a girl, that's what."

I break into tears.

"Why are you crying?"

"From happiness. Everyone said it would be a boy, and I wanted a girl."

Now, despite regular (and quite natural) periods of sadness and grief, anxiety and stress, I have been living with happiness for almost twenty-three years (everything was like I dreamed). My happiness is named Angelina.

*—Anna*

Tajikistan, June 1998. My son is four months old. We're about to go out for a walk, so I have to get him dressed. I choose a cute summery outfit with a "by the seashore" print. I'm anticipating the usual squirming and whining as I put his clothes on, so I immediately start up some patter about how handsome we're going to look in this outfit, how he and Mommy are going on a walk together, and so forth, all the while looking right into his eyes. All at once, I realize from the smile on his face that he is following the gist of this verbal stream and is delighted by my words—that we are accomplices. It's an indescribable feeling to know that this tiny person, who still can't say a word, is in complete solidarity with you—your companion in a small but merry adventure.

*—Leila*

I am nineteen, in 1987. I work during the day and take courses in the evening. I am on my way home on the commuter train. It's late fall; cold, dark, damp; everything is dismal and grey. I was lucky enough to get a seat in the overcrowded car. Suddenly … something inside me kicks. It's unexpectedly strong. Another one. Kick! How is it that I know without a doubt, at this young age, that what I'm feeling is my future child? How do I know that it will be a girl? And where have all the angry people around me gone? Where did the chill and darkness disappear? An avalanche of such love and indescribable happiness descended upon me. I froze and listened: Where are you, happiness of mine? Happiness … after a while, it dawns on me that I am sitting there with a smile on my face that stretches from ear to ear, still looking at the man seated directly across from me. Poor guy, he has probably been wracking his brains to figure out what aspect of his person elicits such a smile. … But I can't turn it off. I'm happy. …

*—Olga*

I am five or six years old, in Almaty, with my grandma and grandpa. I don't want to go to day care, but I have to; so they pull on my red tights and shoes and off we go. All the houses are wooden and it smells like food. I throw a tantrum. Grandma grabs me by the hand, which hurts, but we go back home. She picks up the phone and tells work that she can't make it today. Then she goes to the refrigerator and takes out my favorite thing—frozen chunks of pineapple—and we sit down opposite each other. "You little brat," she says, smiling.

*—Sveta*

You open the door, walk into the apartment, and throw your heavy duffel with the ISAF (International Security Assistance Force) badge on the floor. I embrace you, breathe in your smell, and realize that the long months of waiting are over. You have come back from Afghanistan and will not go there again. That's it. My war is over; my son is home, next to me, healthy and safe. Happiness in its absolute form.

*—Irina*

It's already dark outside. Winter. Out in the countryside with Grandma and Grandpa. I am only three years old. A blazing woodstove overheats the kitchen where we sit. They have already fed me, bathed me, and are probably about to carry me into the other wing of the house to sleep. I catch the murmur of evening conversations, the scraping of a door opening. …

Along with a blast of frosty hair and drops of snow melting off a fur hat … late at night, when I am just about to be carried off to sleep … on the kitchen threshold there suddenly appears … my mother.

She has long since departed this earth, but that avalanche of unexpected happiness has never left me. … To this day I remember every detail of her black coat, the angle at which she leaned against the door, and my sense of gulping with surprise. This, then, is my boundless and immeasurable moment of happiness.

*—Alla*

1995, September. My son is three months old; I bathe him before bed, put on his night onesie, and hold him in my arms. Suddenly, his little sister runs up. She has just turned two; she is all round and curly haired. She looks at me as if she's about to cry and asks to be picked up. Gathering my breath, I reach down and pick her up too. There's a twinge in my back and a familiar stab of tiredness in my legs. One little nose is poking into my chest and the other little nose is breathing on my cheek. I carry them into the nursery. Arms full of happiness.

—*Natalia*

Moscow. It's early morning, I'm out walking the dog, I am thirty-eight years old. Everything around me is green (there are leafy trees, the birds are singing—just lots of green), and my head is spinning with thoughts about work, about my son, who is just about to start college, about the absence of any man in my life. Suddenly I realize that I am a completely happy woman, that I actually have everything I want in life—my mother and my son are healthy; we have lots of family and friends; I have a complex job that I love. So I'm smiling. …

—*Maryana*

For me, it's autumn. I am eight years old, already in second grade. But today is Sunday and I am not in school. I am mushroom-hunting with Grandpa. He is still alive. I have on a knitted pink hat with a pom-pom and a checkered dress. Grandpa keeps fixing the ties on my hat … and he tells me incredible stories. He calls me his favorite granddaughter and tosses me up and down in his arms. Flying up, it's as if I'm seeing everything from the side: myself, Grandpa, a golden forest. And the whole world, which is very peaceful. I am happy.

September 1944. I am fifteen years old. My father came home from the war today. I am holding his hand now. I used to love sitting on his lap, but now he no longer has his legs. Yet he is home. And alive. My five brothers, two sisters, and I are happy.

I am now twenty-seven, and about a year ago I started to study singing. My mother has never heard me sing. Just now she listened to a studio recording of me performing several songs, and she looks at me, smiling with amazement, delight, and pride. I have waited forever to hear words of approval from my mom, but this time I don't even need words—I'll never forget the look on her face.

I am five years old. I can't wait to see my father. He's been on an expedition somewhere on the Atlantic Ocean. He works for a mysterious, but very important, division of the Soviet Academy of Sciences, something having to do with space research. My mom and my brother and I sit down every evening to write him letters. Or, more exactly, they write letters and I draw pictures. In return, we get letters from him, usually all at once, in batches, or the occasional telegram.

    Today is a sunny day in May. I'm at kindergarten. Our "quiet time" has just ended, so we're back on the playground. In walks my father. All in white. He radiates light. Tanned, bearded, joyful. He waits. I don't immediately recognize him. Nobody does. For a few seconds, I don't believe my eyes.

    I run to him. He picks me up and sits me on his shoulders. I'm not only happy—my heart is beating as it never has before, or after, not even from my first kiss or the birth of my children. I still can't explain it. … For me, he was on the same level as Gagarin, Che Guevara, Hemingway. The guys he tells me about. I don't know who they are, I assume they are his friends. Later in life my father would remain just as close to me, and at the same time as distant as Hemingway, Che, and Gagarin.

*—Elena*

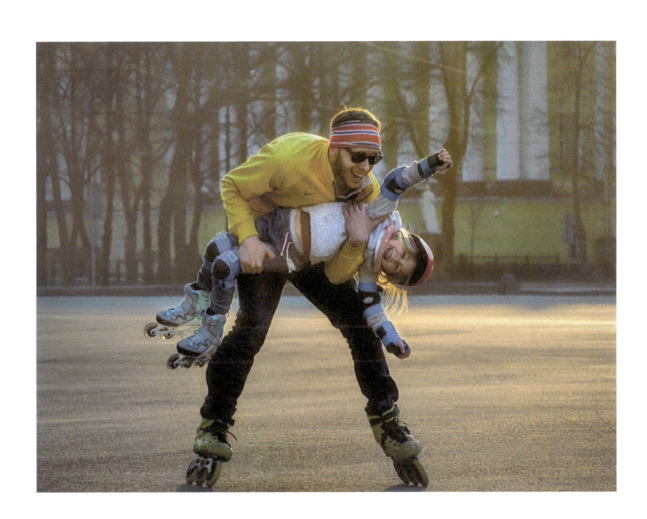

## Chapter Four
## Connections

*In which we are thrilled to discover what is always potentially in our grasp, but so often missed: a moment of connection. It might be a connection to a lover, to a soul mate, to a stranger on the street, to a work of art, or to the secrets of nature. It might be a simple law of the universe: happiness is a form of connection.*

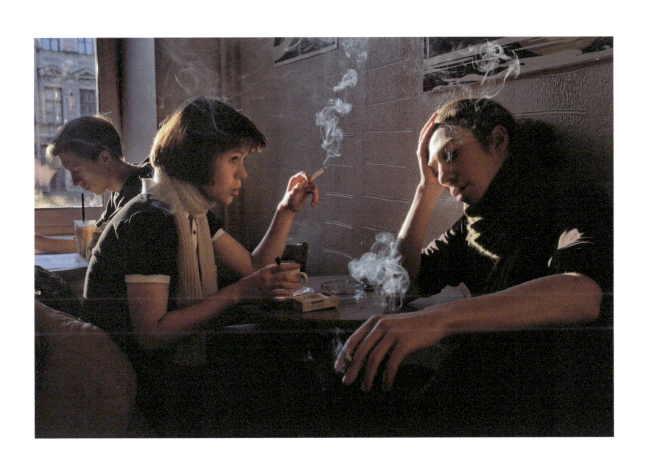

September 1, 2004. I am standing by a grimy window in the corridor of the maternity ward. I gave birth to my son during the night. In a few hours, they will bring him to me for his first breastfeeding. I can feel my legs buckling under me from exhaustion, so I grip onto the windowsill and look out the fourth-floor window. Down below, I see a courtyard and a young man. He has come to find out about his wife, who has the bed next to mine. They are both deaf.

We're all under quarantine because of SARS, so they don't let anyone into the hospital. You can only speak to your relatives by phone. I remember wondering how my neighbor would be able to communicate to her husband what she wants him to drop off for her and their new baby boy?

Now I see. She is standing at the other window and talking to her husband in sign language. Signing through a closed window. Separated by a glass pane and four stories, they stand there and converse with their hands for the longest time, chatting about all kinds of things. Love knows no barriers. I smile at this thought, and in that moment, I realize that I am happy.

I have the body type of Winnie-the-Pooh and a very unprestigious job. My kids are grown, and my wife has left me. It's November, it's dark, and for supper I am boiling a package of dumplings. No woman in her sober mind would want to kiss me. I am impoverished both for real and in spirit. That doesn't stop me from dreaming big. In my imagination, it's all there: treasure, leadership of a rebellion, moving to Brazil, and the love of a beautiful woman. There are lots of beautiful women in my (damn that testosterone) imagination. I am even acquainted with one of them. I stole her phone number and in the evenings I glance at it, to take measure of my current level of self-worth.

With a mental, "Here goes—," I hit "Call." For five minutes the woman will be befuddled, and then she'll hang up, of course. I, on the other hand, will hang onto the memory of those five minutes all the way until Alzheimer's sets in. She *really is* beautiful. So much so, that she could afford to divorce a genuine millionaire. She slammed the door in the face of a famous composer and threw his roses out the window. She has an amazing "*Hel-lo?*" I'd give a year of my life for one of them. I quickly-quickly explain who I am and say that if she's not doing anything then let's go for dinner. For instance, tomorrow. Just like that.

"No …," she answers. "Let's go today. I mean, why put it off?" I guess she was joking with me. And thus began my happiest day. It has lasted for twelve years, our mutual happiness. Sorry this is so long. I didn't have time to write a shorter version.

—*Slava Se*

> Slava Se is the pseudonym of Viacheslav Soldatenko, a Latvian who writes and publishes in Russian. Trained as a psychologist, Soldatenko began his career in psychological testing and evaluation, working first for the Latvian government and then for private human resources companies. All at once, he gave up his professional life to become a plumber (and spend more time with his kids). After eighteen years on the plumbing beat, he published his first book *The Plumber, His Cat, the Wife, and Other Matters* (2010). He is still writing books, and he is still married to his (second) wife.

Why not *now*? So I just came home for lunch, and will have to go back to work later, but right now I'm at home, where everything is cozy and nice, smiles all around; it's warm inside, and my orange cat is installed nearby, broad-faced and judgmental, following my every move with his eyes; so I pour some coffee, stir in the sugar, take a sip, and glance out the window, taking in the noise of the cars going by, the whiteness of the snow that fell overnight; in fact, opening the window vent just a bit, I take in a breath of sharp, cold air and watch a steady, unhurried still life of life.

It's one of those moments when sometimes the frantic beat—traffic lights, honking, rushing passersby, crowds—goes quiet, like in a slow-motion movie, and that's … good.

The year is 2012. I am twenty-seven years old, it's summer, and my wife and I are driving back to visit her hometown in Ukraine. I am happy. Happy because I have this unbelievably gorgeous wife and because this year I bought my own car, used, but my favorite model. My first significant purchase with money I earned myself. We are on our way to her parents. Soon they will become like a second mother and father to me.

The whole way there we are laughing and eating delicious food, which we buy along the way from local residents. This road trip—this movement forward—this is my happiness.

*—Kirill, Moscow*

I went to check on my grandmother because I was worried, and when I rang the doorbell she didn't answer. I had to let myself in with a key. Grandma had died at 11:00 that morning. I felt terrible. Then at 4:05 pm a message arrived: "We have a baby girl! Bogdana." And suddenly I'm sure that Grandma knows, too. So, it was that kind of day.

*—Alex*

I bought a Japanese motorcycle, and that was happiness. Then I sold the motorcycle in order to rent an apartment to share with my girlfriend. And that was also happiness. Then I got married to that girl, which was also happiness. This spring I will buy another motorcycle, and in the summer my wife and I will go riding together. And that will also be happiness.

I'm serving in the far east, Vladivostok, in the air force. In the middle of January 1988, they send me to the Ukrainian city of Nikolaev on business. By slow train. That amounts to twenty days of uninterrupted freedom from duty and the presence of female citizens.

At the stop in Blagoveshchensk, near our northeastern border with China, a beautiful woman named Tatiana enters our wagon. She is traveling to Petropavlovsk, a city in the north of Kazakhstan. I talk to her the whole way, laughing, falling head over heels in love. Two whole days of complete happiness. A parting kiss. Then she leaves, just as suddenly as she appeared. A moment. Happiness.

*—Dima*

Hello. My story is from late December 2012. I am very tired after school, making my way back home from the bus stop. It's already dark outside, and getting very cold. I go into the dingy lobby of our building and decide to check my mailbox. There I find a cherished letter from my best friend. I tear open the envelope as soon as I enter my apartment, without even taking off my hat and scarf. Inside is a long, touching letter and even presents: four guitar picks and eight photos of my friend's hometown. I sit down, smiling stupidly, and read the letter over again.

    Thank you, Andrei, for that wonderful moment.

*—Alena*

Today is September 2, 2012. We are at my sister's wedding and I am the bridesmaid. I look at the groomsman—who is also the groom's brother—and realize that this is the person I've been looking for my whole life. He's right here, across from me, and it really doesn't matter whose brother he is. I fall head over heels in love. That is happiness.

*—Maria*

At age eighteen I arrive in Czechoslovakia for the first time for my studies. Oh, that spring air. Oh, those girls from Holland all around. Oh, the smell of food everywhere. Oh, that melting snow, and thoughts of my girl in St. Petersburg with the curly red hair. We stayed in love for four years at this distance.

May 31, 2011. A night on the beach. A big party celebrating the official start of summer. Beating drums, fireworks. That's the night when I first saw her and fell in love. … We are still together and love each other. On that night, I was insanely happy. Only now it's not insane: it simply *is*.

*—Diana*

September 2009. A warm evening, a café on a street I've known since childhood. I am circling the dance floor with a woman I love, at the wedding of her only daughter. I have loved this woman for a long time, but only three people in the world know about us: I do, she does, and her (our) daughter. Such is the way our fate played out, and such is our little secret. I feel the warmth of her hands and the physically palpable stream of joy that emanates from her. I see the lovestruck eyes of the groom, and the just-barely anxious and happy smile of the bride. Those impressions will reach me later because at this moment I am pulled into the warm, heavy, swirling undertow of longed for happiness. I can't see anything around me; I have no thoughts; I simply give in to the music and movement.

Today is July 25, 2011. My head is lying in the lap of the girl that I love. She is stroking my hair and saying, "Too bad you are not a man. …" I answer: "If you can't change the situation, then you have to change your attitude to the situation." She goes silent. I raise my head and kiss her. Ever since then, we've been completely happy.

*—Nadezhda*

2006. Winter. A week has gone by since I discovered that my much loved, one and only, best ever boyfriend had been cheating on me. I have no desire to keep living. All my thoughts are filled with the same question: "Why?" Not to mention this terrible hangover, which makes the situation worse. As I started to drink beer yesterday, I already knew that today would be bad, because before I even opened the first bottle, I had already set myself a goal. I needed to get down. I needed to get it all out.

Now it is six in the morning; a ring at the door. "My God, who is it? On a Saturday?" The text on my phone says, "Look out the kitchen window." Back then I lived on the first floor. I look, and there's a single rose—such a fresh, beautiful rose, lying in the snow on my kitchen windowsill. It was put there by one of the boys who was there last night, whom I had just met for the first time, and then never saw or heard from again. I didn't look for him to say "Thank you." I had his number, but I didn't need it. The medicine had worked—his gesture cured me. I am HAPPY!

End of August 2004. A big car, and the person the sight of whom, even the thought of whom, makes everything inside me tremble is at the wheel. I am wearing an orange T-shirt, orange pants, and my toenails are painted orange. I am sitting in the lotus position, cross-legged, and he is holding my toe while I blab about something insignificant; and I gradually realize that we have traveled about one hundred kilometers further than our original destination.

"Wait, where are we going?" I ask.

"To the sea. You wanted the seashore, right? Odesa or Crimea?"

"Well, Crimea," I say, dumbfounded.

It's another seven or eight hundred kilometers to Crimea, so we drive all night, and then swim in the sea and sunbathe on the beach for two days, lounging in the evening in beach chairs on the shore, stalking seagulls with our cameras, eating watermelon and ice-cream. We chase each other, sleep in each other's arms, and the entire time words cannot convey how unbelievably happy I am.

It's May 1, 2003. My relationship with this person has just begun.

I'm at his house as a guest. I'm a bit cold and he wraps a blanket around me. We are standing in the kitchen; he is making tea. Every so often he glances into my eyes, as if asking, "Is this a dream?" And I smile because I already know that I love him.

What I still do not know is that we will be together for a very long time and will be happy. It has lasted to this very day.

We got married, got a cat, moved to a different country.

Most importantly, we've already had, and will continue to have, a boatload of achingly happy moments.

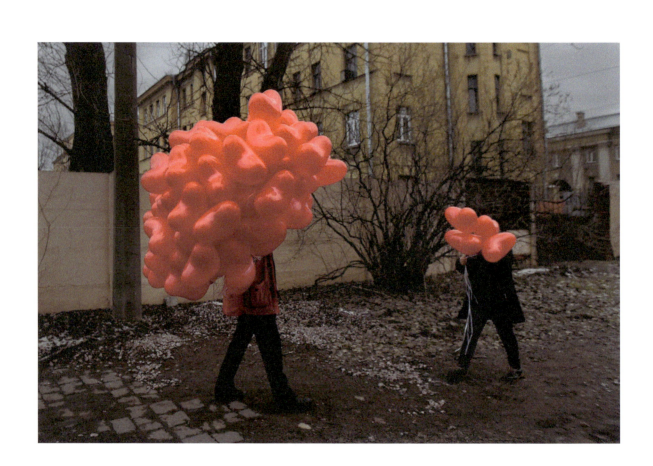

1995. I am sixteen. It's summer. We are spending some vacation time at my friend's dacha. The five of us girls. And my friend's mother. Every morning we go fetch water from a spring, and every evening we go to the village to get fresh milk. It is actually not that easy to drag all that water back, carrying those heavy buckets under the scorching hot sun, but we don't mind. Our room is plastered with big posters of our idols—Garry Barlow, Mark Owen, Michael Jackson, and only a small photo of Vladimir Presnyakov, which I pinned up right above my bed. We listen to our cassette tapes over and over, rewinding them impatiently. We sing songs to the guitar in the evenings, we hike up the nearby mountains, bury "treasures," fall in love with the rock 'n' roll boys from the neighboring dacha, and then feel incredibly awkward about all our posters when they come to visit. We try to take pictures of the full moon with a cheap little camera, wear each other's windbreakers, and sit on the garden pathway until late at night, waiting for falling stars, in order to make a wish … this is happiness!

*—Marina*

October 2000. We are celebrating our friend Caspar's birthday at the dacha on Latvia's Jūrmala peninsula. We decide to get some fresh air and look at the stars. It's chilly outside—we're already regretting having left the room with the fireplace. There's no choice except to bravely wrap ourselves up more tightly and start to climb the hill. Slipping on wet leaves and hugging close to each other, we get to the top and see the moon reflected in the river. Somebody suggests we should howl at it … so now, twenty-three more or less still sober people begin to howl, imitating wolves. At first it was just for fun, but then it turned real. We howled with pleasure. In our howling there was pain, and joy, and suffering; determination and fatalism, hard-won experience, and tantalizing anticipation; you could hear resentments and hopes. … What was that? Some kind of collective trance? I don't know. I only know that I was absolutely happy while I sat with my friends, howling at the moon.

*—Aleks Dubas, radio host*

August 2011. We were sitting on the balcony, and suddenly he says, "The Crimean shore would be nice, wouldn't it?" I can't believe it, but we take off for Kazantyp. After three days and a thousand miles on Ukrainian roads, we arrive in a different universe—one which contains only beauty, music, light, sun, and the sea. We are surrounded by nothing, except smiles, sunsets, and the sense that time has stopped. They say that happiness only lasts for an instant, and that life consists of many such instances. But this happiness lasts for two weeks, and then for another two weeks, and then for another and another: we're infected.

—*Romashka*

Summer 1994. I am at a summer camp near lake Sevan. As it should be, we're all a little bit in love with each other. We're sitting around a campfire singing along songs to the guitar with some of the grown-ups. Nobody tells us to it's time to go to our tents to sleep, which means that now I am also considered a grown-up. One of the guys is passionately singing "I Would Kiss the Sand You Walked Across…," while locking eyes with one of the girls. There's a sense that love, not sticks, is feeding the fire, and we are all breathing its smoky scent of bliss and tenderness. A few meters beyond the fire everything is enveloped in complete darkness. Feeling my way towards the hammock, I lower myself into it and immediately realize that somebody else is already there. I recognize him in a split second by his smell—it's the boy I am in love with! My heart is beating so loudly you would think it can be heard all over. We lie in the hammock, holding hands, and he tells me about the stars and the galaxy. I feel complete happiness and oneness with nature.

1996, and I am fifteen years old. Summer on the high banks of the Volga River. My group has been assigned to work on *plein air* painting. So we're a group of girls settled in among the bushes where nobody can see us. … Our arms are covered to the elbows in oil paint. In one hand I hold a brush, in the other a sandwich (not mine, because your friend's sandwich always tastes better). The slightly bitter taste of black bread dotted with paint (which is incredibly toxic, but who worries about that at fifteen?). In other words, the actual capturing of beauty in painting is not at the top of our minds right now. This female collective is discussing life.

We are saying the kinds of things that usually drive the boys into hiding under the bleachers (that's how ill it makes them). But now we are as free as we have ever been and can talk about everything. Nobody can hear or see us. Just the blue sky, endless distances, the Volga breezes, seagulls. … Our thoughts and feelings are completely free of all constraints. It feels like flying above reality . … And I have no memory of what sort of painting I produced.

*—Nadya*

August 2010. Vacation time. Two weeks ago my lover left me, and I am lost. Out of nowhere, a friend asks me if I want to join their group for a trip to an abandoned coal mine. I say yes, although I've never done something like this so I don't know what to expect. We arrive. Sun, heat, and vast space all around, but I only have thirty-six shots in my camera. Now everything is even more exciting because I'll have to wait for the right moments. I spent those few days like a child—when there isn't a moment before or after, only right now. Here I am about two hundred feet above the ground, standing next to a wheel that's about twice as tall as I am, with nothing but the sun overhead and endless views in all directions. Here we are riding the old handcars, careening around so fast that it feels like we're going to fly off the rails any moment. Then, at night, there is dancing on the rooftop; and in the morning, we breakfast on gingerbread (a local specialty) and wine. I am completely happy! Those few days of vacation seem like a whole lifetime. Now when I look at the thirty-six photos I took, I can still feel it. Catch the wind with all your sails and happiness will visit you—more than once!

Moscow region, August 2009. Six in the morning. I wake up and see a jewelry box on the table, with a note: "Maybe you'll marry me after all?" I open the box and smile, thinking that I will never put this ring on because I can't stand having things on my fingers—although I love earrings. I write on the note, "Of course I'll marry you!" and go take my shower. A few hours later, at work, I am rummaging in my purse to take out my wallet, and I discover another jewelry box. I open it and there's a pair of gorgeous earrings, which I immediately put on. In that moment I am so happy—happy that I love a person who loves me and understands me so well. I am happy!

In January 2012 I return both the earrings and the ring. Our love has gone, but the moment of happiness remains in my heart.

—*Tatiana*

Sometime back in the fall of 2003. I'm in my senior (fifth) year of university and I am hitchhiking back from the Black Sea to Moscow. I spontaneously took off to escape the gray rain about two weeks ago. I have a tent, sleeping bag, kettle, and a liter of cognac in my backpack. Now it's late at night and I'm on the road not far from the seaside resort town Dzhubga. I decide to call it a night and set up my tent in the forest by the road. I boil water for tea on my little gas burner, then add a splash of cognac. I switch on my phone and start receiving text messages from all my friends, wishing me a happy birthday. I share this happiness with thousands of stars in the sky overhead.

—*Konstantin*

About a year ago I suddenly announced that I'd had it: my time is *my* time, I'm going to spend it the way I see fit … ; seems silly now, but that's not the point. I was sick and tired of everyone at the dacha, including my annoying mother-in-law. I stormed out and started to walk through a field of corn. Text messages are still beeping through, there's another notification from Facebook, and I'm still talking to someone on the phone.

I'm talked out. Everyone is stressing me. I charge through the cornfield; the heat is insane; it's the end of August; it's hard to walk across all that stubble; the field is enormous. Finally, I make it all the way through to the highway. I take off my shirt; there's a bit of a breeze, some welcome shade from the clouds, and I keep walking. The batteries in my phone run out, and it dies. Happiness takes hold.

—*Andrei*

2011, Kazan. My girlfriend and I finally started living together. For a few years, we tried having "normal" relationships with other people. Now we are taking off on our first vacation as a real pair. Near the Kul-Sharif mosque, she puts a simple silver band on my ring finger. I understand that I am now part of a family and that we will be together forever. It doesn't matter what other people think. I am happy. And I will not take off that ring.

—*Tatiana*

My classmate Slavik was expelled from school for smoking. It was a long time ago, and now it's kind of hard to believe that it could happen. At any rate, I, for one, was sad to see him go: he was the first boy who ever paid attention to me, the biggest little geek the world has ever seen. He would snatch textbooks from my arms during the break between classes, when I wanted to refresh my memory of the homework. He'd run off down the hall, with me in hot pursuit, trying get my books back—and then some. At the time, I didn't recognize the power of mutual attraction or the fact that our classmates were amused by these childish skirmishes.

Five years later, when I was already at university, I ran into Slava at the railroad station in Perm. We were standing in the same line to buy tickets. He looked at me, but didn't say anything. And I couldn't for the life of me remember where I'd seen that face before—with those taunting eyes—until he cracked a smile. I saw standing before me not Slava the boy, but a grown man, whom I felt like calling by his real name: Slaventy.

He told me that he was serving in the navy. He was on his way now to Vologda, to his fiancée, for their upcoming wedding. We walked onto the platform and talked for a long time about our middle school years. I asked, very carefully, whether he still smoked? "No," he said. "I smoked for a bit in eighth grade, because I wanted to seem more grown up." He added that he had always thought of me as the prettiest girl in the class. And *now* I easily believed him.

It's a July night in 2013, in the desert. Wadi Rum is the most beautiful desert in Jordan. I say to him, "You know, in Russia they believe that if you make a wish on a falling star the wish will come true." "And we believe," he says to me, "that on a magical night like this, when

the stars are so close, God hears your prayers." He looks at me with eyes full of delight and adoration. ... "I prayed for you and for us," he adds.

At this moment I'm happy: that this person is with me, that we meet in different parts of the world, and explore different countries together. Sure, ahead of us lie plenty of obstacles, like convincing our parents that he's not Al-Qaeda and I'm not a Russian prostitute. But right now there's just night, stars, a half-empty bottle of wine, and God listening to our prayers.

# Chapter Five
# Travel as Elixir

*The theme of travel—of Russians abroad—is so prominent in this kind of book that it merits its own explanatory note.*

> Today's global tourism industry exploded well after the end of the Cold War. It took about two decades for a confluence of new forces—open borders between East and West, technologies for booking travel and accommodation on one's own, a burgeoning middle class in Russia and Asia—to result in the massive movement of tourists (the selfie-snapping, inappropriately dressed kind, as well as others) to and from an ever-increasing repertoire of destinations. For many people who came of age in the Soviet Union, the first taste of travel was not envisioned as hedonistic escape, but as a kind of reunion with the landmarks of one's "cultural" life—to see the places where Europe's artists, philosophers, and fairy-tale characters had lived before they took on a second (translated) life as Russians' favorite books, ballets, and museum pieces. As for Americans, who'd had the freedom to travel but stayed put (only ten to twenty percent of Americans held valid passports in the waning decades of the Cold War), these Russian stories about travel are sometimes eye-opening: what one *tastes* when one is tasting a formerly forbidden fruit! Of course, for each new generation, travel offers different types of happiness—including escape, wonder, and the deep satisfaction of returning back home.

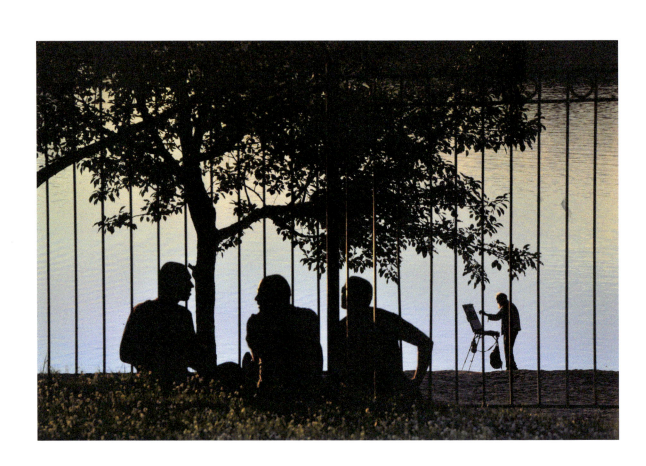

I am still little, only six years old, and I am watching Katanyan's 1964 TV documentary about the great ballerina Maia Plisetskaya. There is a moment where she gets into a gondola and floats down the Grand Canal. This seemed like the *most magical thing* that could possibly happen to a person: to be in Venice, to be in a gondola, to float. ... Then, for my twenty-sixth birthday I bought myself a trip to Venice. I arrived. I got into a gondola. ... And when we were floating down the Grand Canal, towards that famous bridge, I realized what happiness on earth is. That picture, which I had seen on black and white TV, suddenly came alive all around me in full color. Despite the fact that in July there was an absurd crush of tourists all around me—it still seemed to me that something I had dreamed of as a child literally came true. For me, that second probably contained the most concentrated moment of happiness; because I grew up in what was still the Soviet Union, and we all knew perfectly well that to actually visit the real Venice ... well, there was no chance of that ever happening. Yet there I was.

—*Nikolai Tsiskaridze, ballet star*

> Nikolai Tsiskaridze was a member of the Bolshoi Ballet for twenty-one years, departing in 2013. https://www.instagram.com/tsiskaridze/?hl=en.

My first visit to the States. Los Angeles. I was obsessed with this city as a child, but never thought I might actually live there one day. The flight from Vladivostok, via Moscow, across nineteen time zones, did me in. I wasn't able to sleep ... and by the time I got to LA I felt no euphoria at all. All I wanted to do was crawl into a bed and pass out for at least twenty-four hours.

So I'm standing there in the Los Angeles airport, in an enormous line to get through customs. Not in good mood. I glance around the room in a stupor ... and through a small window in the distance, I see a palm tree. A totally ordinary palm tree, the likes of which you can find at every step in this city. But in that moment it hits me that my dream has just come true. I am here, where I have dreamed of living my whole life.

For the next hour, which I spent standing in line, I stared at the palm tree with tears of happiness in my eyes.

December 2012, I am with my mother in Rome. In the evening, we sit in Campo de' Fiori square, drinking a dark grappa. Mama keeps looking around. We keep laughing as we talk about silly things. Her eyes are so happy. She is in Rome for the first time. And it was me who was able to bring her here. I feel so good about this, it almost hurts.

*—Anya*

I am thirteen. We are in Belarus, at the beginning of March: rain, slush, and an icy wind. Train station, tears, and the confusion of leaving forever. Three days later, we arrive in Israel to go on to the resort town of Netanya: shining sea and palm trees. My little sister, my parents, and I stand on the asphalt next to our suitcases, dressed absurdly in down parkas and rubber boots, squinting in the bright sun. There is no way we can cross the road because of a carnival procession—a fantastically colorful array of costumed people and balloons galivanting on the sidewalk. Nobody warned us that our arrival coincides with the day of Purim, the one real carnival day in the Jewish calendar. But in my mind the thought flashes: "*Aha*! So this is what you are like, my 'abroad'! Yes-yes! This is exactly how I imagined life in a different country." At that moment, I am infinitely happy.

July 27, 2008. I ran off by myself to Barcelona. I get a little bit lost while walking through the ancient streets, just watching people, smiling, feeling completely free and happy. I realize that this is the first time in my life that I have felt like this.

*—Olga*

It is towards the end of February 2004 and I am twenty-one years old. I am flying out of the country for the first time in my life, going to visit my friend Sandro in Syria. I step out of the plane into an evening that is warm! Sandro is there waiting for me with a big group of friends. We get into a beat-up old Mercedes and start driving into Damascus. He puts on a Zemfira cassette. Fantastic!

*—Olesa*

December 24, 2010. I've been on vacation in Egypt for a week, and I'm already bored. Just before I left for this much-needed vacation, I ran into a girl, rather briefly, three different times; but from the very first meeting she started to occupy all of my thoughts. So, back to Egypt. … I have just returned from lunch to the hotel. Walking by the receptionist's desk, I hear someone say, "Hello, Vitaly!" This is followed by about two minutes of dead silence as I stare in disbelief and wrap my mind around the idea that Nastya flew here to see me! She dropped everything she was doing in Moscow and flew to Egypt. In that instant, my life changed forever. We had a makeshift wedding on the beach, under the full moon, attended only by the two of us and our vows to each other.

Two years later, we are still together, and I can't imagine it ever being otherwise. I am happy!

January 24, 2012. I am on a boat with my best friend Maksim Sergeevich. There is nothing ahead of us, all the way to the horizon. The shining sea. Look behind us—same thing. We talked three Cambodian fishermen into taking us out, promising to pay them as much as they would have gotten for a day's catch (which was only seventy-five dollars). Our idea was for them to take us to a place on the map we thought looked interesting. At this point, we've been silent for a full two hours. There is nothing to say. We are stunned by the beauty. All I hear is the breath of happiness.

*—Roman*

It is the summer of 2008. I am walking along the banks of the Seine, looking at the artists. They nod at me: "Bonjour Mademoiselle." I pick up a sycamore leaf and it seems more beautiful than any flower. A vendor asks where I am from, and then hugs me and gives me one of those cheap little Eiffel Tower souvenirs that everyone brings home from Paris. I smile back at him. I am happy.

Happy? In an airplane, on the way to Venice—not because I'm on my way to Venice, but just because. I even took a picture of the sky to put in my photo album. A piece of blank sky to record the moment when I was totally happy.

*—Irina*

January 2001. China, the city of Luoyang, White Horse Temple. My boyfriend and I are sitting on a bench listening to the beat of drums coming from the Drum Tower. The sound goes all the way up and down your spine. For some reason it induces a sense of complete joy and serenity.

May 2007. My wife and I are in Paris, sailing down the Seine on one of those sightseeing boats with blurry plastic windows. The audio guide announces that, when sailing under a bridge ahead, you can kiss someone and your wishes will come true. I make a wish that will come true two years later. We will have a son named Daniel. It seems to me that I'd already felt, going under that bridge, the happiness I felt when he was born. Which raises the question: Can my son consider himself a French citizen?

*—Aleksandr*

August 2009. Malta. I am twenty-three. I came here for a month-long language course to work on my English. The trip was spontaneous, like so many of the good things in my life. Now we're at sea and it's already nighttime. A boat party, organized by the school. My new friend, an Italian girl, is next to me. Since we first met two weeks ago, we've spent almost twenty hours a day together, and never once have we argued or grown sick of each other. It's a real test of friendship if you can spend time together vacationing. Friendships that have lasted for years can crash after three days of living together. But with us, the connection has been perfect since the first day, despite the fact that we are both speaking in a language that is not our native one.

  We're hanging onto the deck railing, craning our necks back as far as possible, so that all you can see are stars and the depths of a blue-black sky. A few days ago, I taught her the

dialog out of one of my favorite films *Peaceful Warrior*. Now we yell out our roles in English to the sky:

"Where're you?"
"Here!"
"When are you?"
"Now!"
"Who are you?"
"This mo–o–o–ment!"
My hair is billowing in the salty air. I'm happy!

*—Olya*

November 1976. We cross the border of the Soviet Union, Carpathia, Czechoslovakia, Vienna. A long and exhausting road to freedom. I am eleven years old. It's me, Papa, Mama, and four suitcases. Everything we have in life. Ahead lies Italy, and then New York. Our train car is protected by armed men. After the shooting of the Israeli sports team at the summer Olympics in Munich this year, Soviet refugees are being protected from terrorists.

I step out at a stop and see a little store, a simple station kiosk.

Oh my god! Chewing gum, candies, magazines, toys. Everything is brightly colored, shiny, and begging to be snatched up.

Mama, thank you for FREEDOM!

*—Ellen*

> Something about this historical vignette lays bare the tangled relationship between cheap, shiny objects "begging to be snatched up" and "freedom." The objects are anything but free—their entire reason for existence hinges on whether a consumer will be tempted to buy them. The human being in this relationship is transformed from a free and independent subject into a consumer, who is either seduced into buying chewing gum and magazines (to be spat out and discarded shortly) or paradoxically free to not buy the objects which have come to symbolize "freedom."

Happiness? Right now—right now. This is it. Happiness for more than a year already, every day. I understand it, I'm aware of it, I catch it and enjoy it. I have been freed from all unwanted obligations. My job is interesting. A Muscovite through and through, I have moved to Central Asia. I relish the sunshine here, the dry climate, the fruit, the people. I have friends who are willing to support all my crazy ideas. I have a large apartment in which we gather regularly for themed parties and creative evenings. I have enough money to afford all my "I wants." I do art and have time to think a lot. I have the strength and desire to move forward. I am surrounded by interesting people. I listen to great music, read books, and go down my list of must-see films. I am truly happy right here and right now.

—*Ekaterina*

May 15, 2011. I'm finally back in Russia! After a long period of work in the humid, cloying, sticky heat of Yemen. This morning my plane landed in Moscow, and now, after several hours by train, I'm about to get home to my friends and Tanya! I got to know Tanya not long before I left, and since then we've grown ever closer through our letters. So much closer that recently I've started dreaming only about her. We're on our way straight from the train station to the banks of the Volga, where I'll get to drink shots of vodka with a pickle chaser. The happiness isn't in the vodka, it's in the feeling of being truly home. With the woman you love sitting next to you. Half a year later we get married. I'm still happy.

January 2013. I am twenty-six. I am on the bus, somewhere between Laos and Cambodia. At the beginning of December, on a Wednesday, I lost my job. On Thursday, I bought a discount one-way ticket to Bangkok. There wasn't a lot of time to think things over—the New Year holidays were approaching—so without further consideration I bought the ticket.

    I hug the backpack on my lap and stare out the window at rice paddies and wooden houses on stilts drenched in the light of sunset. Doors are wide open, their inhabitants are lighting evening fires, kids are running around. The music in my headphones provides an ideal soundtrack to this moving picture.

I catch myself thinking that I love everything about this, even the occasional motion sickness. I love my walking shoes and this heavy backpack. I love these endless green mountains. I love the people that this trip gifts me—I'd like to gift each of them one of these Ikea inflatable neck pillows, they are so comfortable. …

I discovered a new nationality—the nation of backpackers. It's a new world, a world in which every meeting of eyes is inevitably followed by a smile!

Every new day is like one of those Kinder Surprise eggs, except, unlike with the toys, the surprise inside is something pleasing and never repeats itself.

I like that my living conditions are not always entirely comfortable, and I like it that I like it that way. I even enjoy being angry about the mosquitos biting me.

I like that, in this reality, the idea of worrying how much a purse costs or whether it's a fashionable brand seems completely idiotic.

I am no longer preoccupied with constructing my future, with thinking about what lies ahead—I am living entirely in the present. This is seriously amazing because normally I am constantly planning for the future. I like the movement. I like leaving the table with the feeling of being not quite full, the feeling of never having quite enough of either the people or the place. It's fun being with these people—you continue to meet them at various points along the route, and the further you go the more you run into each other. Everyone recognizes each other. You run into people who seem to be kindred spirits from the moment you meet them, as if we had all met somewhere before in a previous life.

I have never felt so free in my life. This has been a gigantic, pure, and shining happiness.

I like to look at the map and see where I might go next, but I no longer plan. Just follow the flow … and travel!

*—Olga*

2009, July. I'm closing my eyes and remembering Agadir, Morocco. Your nose is assaulted by the smell of garbage, mixed in with the aroma of seafood frying, notes of hashish. I'm in the center of Agadir, in the souk, which is their word for outdoor market. Stepping over crushed rats and muddy rivulets of what started out as grapes, watermelon, and honeydew I run into a friendly Berber. "Do you like it here in Morocco?" he asks in English. "Yes, I do!"

I am not saying this out of respect for a foreign culture or even out of politeness. I really *do* like it here.

When was the last time you saw happy people? People whose happiness does not have to do with what they have or own?

Go to Morocco and see for yourself. They really *live* there: they dance, they play the guitar, they do handstands and push-ups all along their long stretch of the Atlantic shore. …

It doesn't matter here what you wear, or how old you are.

You start to understand the expression "It's just life. Take it easy" here.

I know that Morocco has changed me: I've become a little bit prettier, a little bit freer. I hope to hold onto this feeling for a long time, the feeling of running down the beach for miles because I was too happy to stop moving.

*—Anastasia*

Summer 1996. On the coast of Italy, on a beach. It's overcast, but warm, with a soft wind. Two very tanned people wearing white are walking along holding each other's hands. She is carrying her sandals, he is carrying a half-empty bottle of wine. That's happiness.

*—Dmitri*

Summer 2002. I am living in Japan, in Hamamatsu. The FIFA World Cup is on. Today was Japan versus Russia. Our team lost, 2–0. I'm in a bar, surrounded by Japanese and a few other foreigners from Australia and Britain. Everyone is celebrating the Japanese win. I'm the only Russian here, and I feel bad. I feel bad for our team. … I mean, nobody thought the Russians would lose to the Japanese. … I feel so bad that my throat chokes up and I can't help starting to cry. Seeing my tears, the bartender picks up a microphone and announces: "Today we have a guest from Russia. She feels sad, because her team lost today. Let us apologize to her, for Japan has won and this made her cry!" Through my increasingly copious tears, I see young Japanese approach me, hugging me, and genuinely trying to apologize. Now I am crying because I am so touched by their empathy. I can't stop, and they keep coming, asking for forgiveness. At

this point I start to smile through my tears, and they are so glad. They hug me. I love them so much! It doesn't matter who is Japanese and who is Russian. … I am happy. Soccer doesn't matter. What matters is this humanity.

Spring 2008. I am in the airport in Atlanta waiting for my flight, watching a young black woman in a pink hat pouring her emotions into her phone. Two flights down, one more to go, another two hours until we see each other. …

We've been apart for a whole year. It feels like a lifetime has passed during that time. Now I am starting to feel victorious for overcoming this trial.

I am seated in the plane now, unable to calm down. I can hear the beating of my heart.

We land at 11:00 pm. Outside it is dark, except for the twinkling lights of a small southern town in the distance. I disembark from the plane into an uncrowded airport. I can feel my agitation growing with each step. Now I'm in the arrival hall. I search for him among the others. There's a group of young people with balloons, and an elderly couple … and off to the side, he is standing there, also searching for me with his eyes. I go up to him and for a moment we freeze, one step away from each other, unable to speak. Two long seconds and then a wave of emotion, tears, and hugs. The happiness of meeting after a long separation is beyond words.

*—Anna*

March 2013. Texas, America. We've been living here for seven months, since my husband was transferred here for work. Unfortunately, or perhaps fortunately, he didn't like the way the business operated locally, so he gave notice and quit two weeks ago. There's nothing to keep us here now, so we decide to take one last trip and drive to Houston. In Houston, we walk around, visit the NASA museum, and determine that the last stop of our journey will be the island of Galveston, which lies just off the coast in the Gulf of Mexico. We drive down the highway, take the exit off towards the island. Suddenly the typical landscape of single-storied America changes into what looks like the set of a period movie: we arrive into a different world of whimsical little wooden houses and nearly empty streets, as if we have time traveled back to the beginning of the last century. We drive straight through the village. Along the

shore we find tiny motels and bars for the surfers. The outdoor tables are filled with people of all ages; and at a glance you can see that they are enjoying life and that they emanate some kind of inner freedom. We see a bar on the beach and decide to have dinner there. Some musicians are playing, and you can tell that they are not just playing for the money—they are playing music in this bar because this is their life, and they love it. We each get a margarita and walk off to the beach; snatches of the music follow us. A strong breeze comes off the ocean, into which the sun is slowly sinking. I take off my shoes and run after seagulls by the water, while my husband videos, sips his margarita, and feels joy. I don't know what made the biggest impression on me—the village itself, the Mexican gulf, the people here, or the margarita. Or maybe all of them together. But it hit me at that moment that we were absolutely happy. An overwhelming sense of limitless freedom, lightness, joyfulness, and *life* poured over me.

A few days later we return to Moscow. We are temporarily unemployed and don't know what will happen next, where life will take us, or what difficulties we may encounter in the future. But in that moment of happiness, my fear of the unknown was transformed into curiosity and a thirst for new adventures. We are young, we are free, we have each other, and life is an endlessly interesting opportunity to find new experiences and catch moments of happiness.

—*Maria*

> All Russian readers will recognize *Odnoetazhnaia Amerika* [Single-Storied America, published in the USSR in 1937] as a reference to Ilf and Petrov's beloved and influential travelogue, which provided Soviet readers with a sharp but humorous picture of ordinary America, based on the writers' travels through the country in a Ford car in 1935–36. It was translated into English as *Ilf and Petrov's American Road Trip* (2007).

Summer 2003, I am still living in Japan because I have a wonderful job and lots of friends. On a late Saturday night, I am walking home from a party. I am by myself, on foot, because in Japan this is absolutely safe. The party was wonderful—I hung out with all my friends and even fell a little bit in love. I am striding through the night now, completely happy. Suddenly, completely unexpectedly, it starts to rain. Large, warm drops fall out of the sky, and I have no umbrella.

But a second later, I am already glad I don't have an umbrella. I tilt my face up to the sky and stand under a street lamp. Out of nowhere, I see heavy shining spheres of different sizes rushing towards me, and along the way they resolve into intricate patterns. The patterns keep changing, and they look incredible against the blue-black sky. I move from lamp to lamp, standing under each one for about five minutes, with my face lifted towards the sprinkling, sparkling sky.

Suddenly another face is right next to mine. The clear and friendly face of a young Japanese man. Evidently, he is a noodle maker for a nearby food stand, because he's wearing an apron and has a dish towel wrapped around his head. He looks at me and smiles.

"What are you doing here?" the face asks.

"I'm watching the rain."

"Show me how you do it, I want to do the same thing."

"It's easy! Lift your head up, squint your eyes and look. If you see a big drop, try to follow it. Great! Do you see patterns?"

"Yes!"

"Do you like it?"

"Wonderful! I've never seen anything like it before! Why do people ever hide behind umbrellas when this is so beautiful?"

"I know! Let's yell together as loud as we can: Life is Beautiful!"

"But it's nighttime!"

"So what? Let's do it!"

The face gives me a conspiratorial look.

In the next moment, we both scream as hard as we can, "*Jinsei ga subarashii*!"

Then we ran off our separate ways, as fast as we could go.

I didn't catch my breath until I got all the way home, wet to the bone, but incredibly happy.

—*Elena*

My name is Anya. This is February, 2013. I am in Thailand, very far from home. I was brought here by an unusual work assignment. I am the photographer for a large international conference. I've managed to fall in love with a gorgeous Polish guy who is also here, with the quintessentially Polish name Krzysztof. This infatuation isn't mutual, but it's still lovely and romantic. I figure out a way to get into the same group that he is in for conference events. So now we are being taken

to some kind of nighttime outdoor market in Thailand. We all get lost there. I'm so annoyed and sad; I can't find anyone, I don't know the way back, and I don't want to buy anything at this market. Finally I hear some music coming from a little café at the end of a narrow street. Familiar rock 'n' roll music. I stand in front of the café and, unexpectedly, I start dancing. Just as I am, with my backpack still on my back, I dance to the music by myself. Until the owner of the café comes out and offers me a beer. My life suddenly turns light and beautiful and I feel unbelievably happy. At that moment, somebody taps me on the back. It's that Polish man, Krzysztof. He offers to slow dance with me. Now *that* is a moment of happiness that words can't express.

A few years back, we were on our way to perform at a festival. It was one of those times when the airports had just put into place yet another set of idiotic security measures. As soon as we started through, they quickly and gleefully confiscated a bottle of whisky that our photojournalist had bought entirely legally in the duty-free shop. Something about the speed and the glee with which this operation was carried out got my hackles up.

So, defending our rights and reaching for the bottle—I'm the kind of guy who creates incidents for the right reasons—I started to question them: What just happened? Where is our bottle? I ask both the woman in charge of patting people down and the garrulous police officer next to her. The more I persist, the more it becomes evident that the whiskey bottle is not in the trashcan for confiscated liquids. "Maybe the cleaning lady grabbed it." Obviously not true. I dug in and demanded to see the head of security services, a nice woman who came over and looked at me with understanding eyes. I grabbed one of our recording devices and asked her for her name, her rank, and the start and end time of her shift. Then I said, "Ok, that's it. We have a flight to catch!"

I can't tell you how sweet it was, that stab of perverted post-Soviet happiness, when, as I was settling into my seat, I saw the pat-down woman and the policeman, both puffing breathlessly, stick their heads through the cabin doorway, which was about to close. Thrusting the poor bottle at me, they cried, "It was found! It turned up!"

—*Vladimir Vishnevsky*

Vladimir Vishnevsky (b. 1953) is a well-known Russian poet, comedian, and entertainer.

On the 22nd of August, 1991, I flew out of "putsch-ing" Moscow to a theater festival in Edinburgh. After a week, the festival was over and it was time to return home. Despair. At the last minute, it turns out that, thanks to some friends of friends, I can stay for free in their empty apartment in London for a whole month. Fantastic! I spend almost all the money I still have on a video camera, the first one I have ever held in my hands. I get up early in the morning and wander through London all day. I come back after dark, buy a sandwich (half price at this hour) and a can of beans, for a sum total of one pound. Every day for a month. I'm starving. It also happens to be an unbelievably hot September in London. I return unopened the umbrella I bought on the first day here and get twenty pounds back from the store. That allows me to buy another cassette and to finish filming my "rainy" London *oeuvre*. I am continually hungry and exhausted by the heat ... but I have never, ever, been so happy— not before, not after. Because this was my first taste of the feeling of complete FREEDOM.

Postscript: later on I made four thirty-minute films out of those videotaped materials, titled *The Scamp's Travelogue, or From London with Love*—and the rest is history.

—*Dmitri Krylov, still hosts his popular TV travelogue for Russian viewers all over the world*

> Dmitri Krylov was born in 1946 on a ship at sea during a storm, perhaps prophesizing a life of travel that would be kicked into high gear by one of the twentieth century's most consequential political storms: the coup that toppled the last Soviet leader (Gorbachev) in August 1991 and that led to the dissolution of the USSR a few months later. The communist regime's near-total ban on travel outside of its borders was one of the "non-freedoms" that Soviet citizens felt most acutely. Knowing that one would *never* be able to visit Paris, or Italy, or other hallowed destinations amplified the desire to do so in ways that casual Western tourists would find hard to imagine. For those who grew up in the Soviet Union, an enormous number of "moments of happiness" were later experienced abroad, but not as moments of hedonism or escapism! For these Russians, the moment abroad is the happiness of recognition— of real castles that used to be castles in the air.

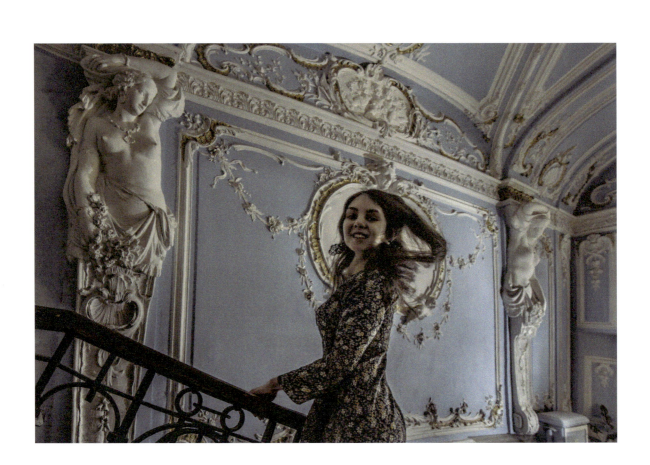

# Chapter Six
# The Art of Happiness

*In which it seems that the more we think about happiness, the more territory it claims for itself—on stage, at the edges of tragedy, in moments of disruption, when we're laughing, when we are struck dumb by a revelation, when ... what do you think?*

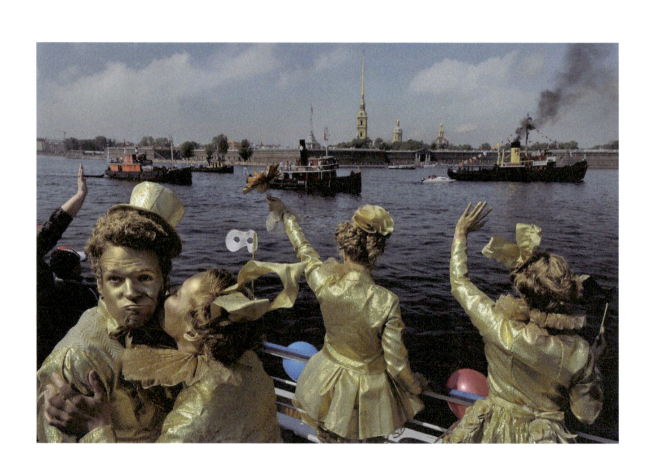

"Happiness equals pleasure without regrets." I read somewhere in Leo Tolstoy. My story is about one of those moments. In general, I've been happy for many years, since I love my work, I love my wife, and I'm surrounded by close friends. So far, knock on wood, I've not been distracted by any health problems.

But here's the moment that still moves me: I'm in the city of Kharkiv (Ukraine) in the central square. Somebody once told me—although I never verified this fact—that Kharkiv has the largest city square in all of Europe. It's the summer of 1993 and I've arrived with my band Bravo to play at some kind of big holiday celebration. The concert is free; anybody can come to the square. They say there were half a million people there. We couldn't even see to the end of the crowd. I come out onto the stage to welcome our audience. But the microphone jolts me with an electric shock, right on the lips. It's not so much the pain, but the unexpectedness of it. I say the f-word, very loudly, to which the crowd reacts with a twenty-minute ovation. I liked that. As an artist, I felt absolutely happy. Completely at one with my people.

—*Valeri Syutkin*

Valeri Syutkin (b. 1958) is best known as the lead vocalist and songwriter for the iconic Soviet Russian rock 'n' roll band Bravo.

The year is 1981. Our movie theater is running the films of Tarkovsky. My father gave up his ticket to one of his friends. So now Dad's friend and I are walking home in a philosophical mood brought on by our viewing of the film *Zerkalo* [Mirror]. "Lenka," he asks me, "were you ever happy, at the moment when you sensed that feeling? I mean, why is happiness always something we feel in the past, but not in the present?" I am fifteen years old, and just today the boy I'm in love with at school gave me such a look. … And here I am, on the same day, talking about serious things with a grown-up for whom I have so much respect. … I answer, and feel at the same time that I am happy right now! Even thirty years later, as I recall that moment, I light up inside!

—*Elena*

> Andrei Tarkovsky left the USSR in 1979, where he faced too many obstacles to his *auteur* vision of cinematic art and philosophy. Globally recognized as one of the greatest directors of the twentieth century, his films were allowed only limited runs in his homeland. *Mirror* came out in 1975.

Happiness is fleeting. Once I was playing the role of Richard III in a Vakhtangov Theater production, the best in Moscow. There were moments during scenes with Michael Ulianov when I felt like I was flying above the stage. That was happiness.

In general, all new impressions bring happiness. Moments that take your breath away. That happens often—especially in the mountains. I was lucky enough to have gone through school in Almaty. The Van Gogh colors of the peaks around Almaty alone are enough to get you through life! Every memory of my childhood and youth is saturated with color. Happiness, you ask? Peace and Freedom. Peace at home, and freedom. Once I heard Andron Konchalovsky at a rehearsal say, "Happiness and freedom would mean traveling wherever I want to and being paid for my work as much as I think I deserve." That might be one ruble or one hundred rubles—the main thing is peace of mind, knowing that what you got is fair. Fairness is important. And the happiness of knowing that your home life is tranquil and hopeful. For instance, our apartment in a high-rise in Novo-Peredelkino, outside of Moscow, has this little balcony. You go out onto the balcony—with your three dogs, Marina, and our little daughter Sasha—and what could be better? Sky above our heads!

Okay, here's a concrete example. I was lying on the floor of the stage of the Bolshoi Drama Theater. During the finale. I was playing King Claudius, but simultaneously I also had the role of Hamlet's father's ghost. It was one of Robert Sturua's productions, not performed in his experimental theater, but here, at the Bolshoi Drama. So I'm lying there. A few seconds from now the bows will start, along with cries of "Bravo!" I can feel it—the production worked, the performance was successful. Actors and audience experienced catharsis. So I'm lying there thinking: "You play in Sturua productions. You play Shakespeare. What else can you desire? You have received everything. This is happiness."

Happiness is in the seconds just before the applause.

*—Alexander Filippenko*

> Alexander Filippenko (b. 1944), is a renowned Russian stage and film actor. He plays the "jester-translator" Korovyev in the Russian film version of *The Master and Margarita*. He is often associated with Robert Sturua, a Georgian director known internationally for his original interpretations of Brecht, Chekhov, and Shakespeare.

In 1996, I returned to Moscow from Canada, from Toronto, where I had lived for almost a decade. It was a homecoming, a reunion with my native city. That was a moment of happiness in and of itself—to hear the sound of my native language all around me, to be part of a large family, not just fellow citizens, but people who speak to me in my language. I felt that these were my people, that we are all related. That was a very concrete, powerful emotion. Yet the real moment of happiness—is opening night, the show's premiere. When I come out on stage at the end and see the elated faces of the actors and the audience, applauding each other, that is the true moment of happiness for me. It means that six months of my life were not spent in vain, because we created something; we managed to make it more or less human and understandable. Of course, the life of the show will tell how understandable it really is—how long will it play? A year, or two, or three, or sometimes sixteen years, which is what eventually happened with *Khlestakov*, although it's hard to predict in advance. When the premiere of a new show goes well, that is a form of absolute happiness. It creates an aura of happiness. It makes people happy. If more people created things together—it doesn't matter what: films, theater, beautiful cars, as long as they co-create and take joy in the process—we would all be very happy humans.

—*Vladimir Mirzoev*

> With a Soviet degree from the Department of Circus Directing, Vladimir Mirzoev (b. 1957) emigrated to Canada, where he found a cutting-edge theater group called Horizontal Eight. What was at stake in the show described here as "more or less human and understandable"? Would a ballet-opera based on the mystical teachings of the late nineteenth-century guru Georgy Gurdjieff capture the sense of *The Search for the Miraculous*? https://ggurdjieff.com/ouspensky/in-search-of-the-miraculous/.

My moments of happiness usually happen when I've written a lot of material. For instance: I had been sitting in Odesa and writing for the entire summer, and then, one night towards the end of this period, I am scheduled to perform on one of those restaurant barges which docks below Odesa on the Danube. They are setting a long table, enough for about forty to fifty people. Buffet stations include meat kabobs, all-you-can-eat crab, bouillabaisse, and so forth. As I take the stage, the barge is moving, the incessantly swearing helmsman is steering. Not exactly steering, that is, but yanking the barge around with a tugboat every time the barge bangs into the shore. *Bang—yank, bang—yank*, that's how he steers. There it is, my moment of happiness. I don't need a word of what I had written. The audience is already convulsed, they are totally getting it, they are practically in tears: *Bang! Yank! Bang!*

Later we get off the barge and go for drinks somewhere on shore. Have something to eat. Move on to another spot—that's a moment of happiness in my book: the end of summer, mid-September, and a barge yanked around by a tugboat.

*—Mikhail Zhvanetsky*

> Mikhail Zhvanetsky (1934–2020) is a Russian Jewish satirist and comedian known as the "patriarch of Odesa humor" and loved by all.

May, 1998. St. Petersburg. I am a third-year student at the Theater Institute, rehearsing the role of Juliet. Nothing is right. Our instructors have been saying that Anechka, another student, doesn't quite have this aspect right, and Julia hasn't quite mastered this other thing—but you, Alisa, *you have it all wrong*. When I hear this, I run out of the building sobbing, and keep running. I go down Mokhovaya Street, turn toward Palace Square, and end up on the spit of Vasilyevsky Island, the most beautiful spot in all of St. Petersburg. There is nobody around. A heavy rain has started to fall; in fact, now it's a downpour. The Neva River is huge, and the waves crashing onto the spit are enormous.

I continue to stand there, alone; all the tourists have disappeared. Thunder, darkness, wind, lightning. On the one hand, I'm really frightened, because it seems that any moment

I'll be washed into the river by a wave. I am already soaked through by the spray and the storm. I am sure that when lightning strikes the Rostral Column it will strike me as well. I stay and observe all this. I start to think, "My God, this is it, becoming one with nature, joining the elements. Now we are a pair—the elements and I, the Neva and I, the torrents and I, the thunder and lightning are also me. They are part of me, and I am part of the whole."

In that instant, I suddenly understand that I am completely happy.

—*Alisa Grebenshchikova*

> Alisa Grebenshchikova (b. 1978) is a Russian television personality and actress. She is the daughter of legendary Leningrad rock musician Boris Grebenshchikov, founder of the group Aquarium.

On June 11, 2012, Roma, my eight-year-old, and I were on our way back from Sochi, where we had attended Kinotavr, the biggest film festival in Russia. As we were landing, I switched on my phone and saw a text message saying that our film *I Will Be Nearby*, in which my son played the main role, won the prize for Best Film of the Festival! I shout out the news to the entire airplane, jumping up and down and hugging my son, feeling everything at once—joy, excitement, pride in my son. As I write this, my stomach is still in a knot. On top of everything, it's my birthday today; we'll go home and make fondue and celebrate.

—*Alena*

> The 2012 winning film *Ia budu riadom* [I will be nearby] is a Ukrainian Russian production that tells the difficult but ultimately heartwarming story of a single mother and her six-year-old son, played by Roma Zinchuk. The mother, a restaurant manager, has a form of terminal brain cancer. She sets out to find a new set of parents for her son while she still can.

I think there are essentially only two types these moments. The first has to do with accomplishment: you wanted to achieve something and you made it to the top of the mountain. That covers things like conquering a woman's heart, acquiring power, getting rid of a disease. The second type is unexpected. This kind of happiness does not depend on you; you did not go for it, you didn't even desire it, but it chose you. The happiness of accomplishment is ephemeral; the minute you grab onto it, it's gone, and things are already worse. After all, you can't stay long on the tip-top of the peak, and there is nowhere to go but downhill. Whereas unexpected happiness can hang on. I'll give you an example.

This happened in the region around Mtsensk, that classic provincial Russian landscape. We were shooting the movie *Fathers and Sons*. To celebrate the first successful week of filming, there was going to be a party down by the river. I liked all of this: I like the Turgenev novel that we were filming, and I liked the cast and crew that had come together for this project. So I was in a good mood—but that is beside the point.

I was walking to the river by myself, since I was running late, and everyone else was already at the party. Then something unexpected happened. I saw a landscape that completely stunned me. I beheld complete harmony: the height of the trees in proportion to the flat surface in front of them, which was overgrown by some kind of magical, primordial grass, grass that was simultaneously uncultivated and mindful of straight lines; and this landscape was illuminated by that time of day, around six on a summer evening, when everything shimmers in stillness. I stopped in my tracks, in the midst of this vision, and I didn't move from the spot for a long time. This is the moment when I said to myself, "*My God!*— this is happiness, happiness!" I probably stood like that for fifteen minutes. I was struck most of all by how it all came together: nothing depended on anyone's actions, it took no mental or physical effort of any kind to hang onto perfection. It just fell into place, an ideal of pure harmony: the colors, the sounds, the lighting, and my accidental presence as a part of it all.

You asked me to remember some of the moments of happiness in my life. Were there pleasant moments, triumphant moments, inspiring moments? Of course, all of those. But I wouldn't call those moments happiness. For me, happiness is the tantalizing possibility of synchronicity, when everything aligns unexpectedly. I have probably experienced it many

times, and then forgotten. This recent experience, however—well, I remember it and I'm trying to recreate it.

—*Sergei Yursky*

> Sergei Yursky (1935–2019) played lead roles in dozens of Soviet and Russian films throughout his long career.

Spring 2003. I am fourteen, and I am going outside for the first time since learning how to walk again, after my legs were amputated. A simple walk around the sunny courtyard with my parents—that was happiness. In general, every time you do something that you couldn't do before, or thought you couldn't do, in that instant happiness shoots through you. It makes me think of another such moment: three years earlier, in June 2000, we were at a choir championship in Spain. The city of Tolosa was hosting the contest for best singing choir in Europe. Up until that year, they had never let a children's choir participate in the contest, but our group had won so many prizes they decided to let us in as a kind of experiment.

All the choirs have performed their programs, and we are waiting in a room watching some kind of show while the jury deliberates. A woman comes out onto the stage, talks for a while in Spanish, at the end of which we hear "Coro infantil Vesna!" That means that WE'VE WON. As I write this, tears come to my eyes. But at the time we all simply sobbed, watching our beloved choir director going out onto the stage to accept the prize. That was an unforgettable moment of pure happiness.

A warm spring day: the sun is shining. I am walking home with my girlfriends from school, through the streets of our military town. We are all about twelve years old. There are four of us. It's fun—we chat away about nothing in particular. Three officers are walking toward us. They turn out to be the fathers of my three friends. I catch myself thinking that it's a strange coincidence that we should meet all three of them at once. But my father is not there: he is away at war. My mother and I are waiting for his return. Suddenly, I think how nice it would be to arrive home and see my father there. I resolutely toss off that thought—my mother has

told me that it is still too soon for him to return. We all continue on our way, my three friends and I, and their fathers.

I go up to the second floor and ring the bell. The door opens … my father! My screech of happiness can be heard through the whole building. I jump into his arms and wrap myself around him. That was a moment of real, big, childish, human happiness.

May 1982. Demobilization. I left with an army torch and promised myself, "I will set this off at the happiest moment of my life." About ten years later, I realized that I had set myself a trap—how will I ever determine which moment is the happiest? What if it has already come and gone? What if it hasn't arrived yet? In the meantime, the torch has disintegrated. …

—*Vladimir*

Happiness is an ephemeral and inexplicable thing. It can last from a few seconds to a few years. It can be felt as a quiet, even illumination, or as a sudden flash. It can come out of nowhere or out of very strange circumstances. Happiness can even arise in situations that are not conducive to it at all. …

Year before last. January 6–7, Orthodox Christmas. I am singing in the choir for the holiday services for the first time. I am also incredibly busy: working on my master's thesis, church services, the daily three-to four-hour roundtrip commute—home–school–Grandma's–home—basic household duties; in short, pots and pans mixed up with harmonies and arias. Now—two days of slowing down. It's Christmas Eve. The evening service has ended and I have over two hours until the Christmas morning service begins. I walk through the arcades of the grand GUM store on Red Square, sit for a coffee in one of the coffee shops; holiday lights sparkle on the glass-paned ceiling. The music is low, and there are not a lot of other visitors to the mall at this time. It's so peaceful. I sit by the window, looking out onto the street, a dark-blue sky lit by city lanterns and a few car lights going by, and I feel so good. I'm happy!

May 28, 1971. Today is my twenty-first birthday. I am with my friends in the mountains of Kirgizia, where we are on a hiking trip along with many people we don't know. It's one of those soft, dark, southern evenings. There are many tents all around. We are sitting by our campfire and singing Vizbor songs to the guitar. I can hear a few people whispering, "That Katya from Omsk—it's her birthday today." Some of them disappear for a while; and then, about half an hour later, I see that on the slope below us they have constructed a gigantic fiery "KATYA" out of twigs and brush tied together with rags. I am completely happy in this feeling of both total freedom and a kind of togetherness with everyone around me.

Well, I'm happy right now, at this very moment, even though it's been raining all morning, my feet are wet, my head also. … But I woke up in the forest, next to three people with whom it's nice to do so. One of them has been by my side for seventeen years, the others less than that—after all, they are not even grown-up yet. Not to mention that right over there is our friends' tent; but, as always, I was the first to get up and go for a dip in the river, bare as bare, no swimsuit needed. … I brought back spring water from where it feeds into the river, and my son and I are making tea for everybody, now, as we speak. … Thanks to the internet, and thank you for the chance to tell this story.

*—Andrei*

I am six years old. It's summer, it's hot, and I am lying on my stomach in the garden, poking my head through the tall grass. I have a very important mission—I am studying the life of insects. It is cool in the grass and it smells of dampness. I see everything extremely close-up: the earth, the stalks of plants, and busy bugs doing their thing. This huge and secret world enchants me and piques my curiosity. Endless minutes of concentrated happiness, peace, and oneness. …

*—Elena*

That wonderful feeling when through your sleep you hear the sound of maintenance shoveling snow off the sidewalks. You quietly peel open one espionage eyelid. You ascertain that it is still very dark out, so it must be at least a half hour before your alarm goes off … and you start to sink back into sleep. And that last thought, right before you fall sweetly back into slumber, "How nice it is that the brave maintenance crews battle the elements so early in the morning. And how nice it is that I am not one of them." I mean, there but by the grace of God might I have gone to prison, into poverty, or into the army; but how nice that it worked out differently and I got an education, and that when morning comes I will share this thought with my son … except a luxurious yawn cancels all thought and plunges me back into predawn sleep.

*—Aleksandr*

My great-grandmother's story. April 5, 1942. Besieged Leningrad.
   "It's my birthday. My daughter comes home after two shifts at the factory. My son arrives with his fiancée. We all live together in a communal apartment. It's easier and warmer to be close together. We're going to make a celebratory dinner: pea soup and bread. Real coffee (the last of the two kilos we bought right before the blockade started last fall) with saccharine for dessert.
   My daughter carefully unwraps a package and hands me a real, fresh cucumber! My favorite vegetable! To this day, the cucumber's smell of freshness and spring is associated in my mind with magic and happiness. …"

*—Inna*

A happy day in 1952. The March sun was so bright, heaps of snow sparkled all around, as if we were on the set of *The Snow Princess*. Mama and I were going to ride the trolleybus, the metro, and a tram all the way to Ostankino, which was then still on the outskirts of Moscow. Mama wanted to bring a gift to the massage therapist who worked on my back. To express our gratitude, Mama had bought a beautiful, blue jewelry box, and inside, nestled on blue satin, where two little bottles of perfume. How I loved that wonderful little box! And how wonderful

it was to travel this far with my mom and then step out into the clean frosty air of the suburbs. We started to look for the massagist's home address, and when we found it, I was amazed that in this part of Moscow there were still ancient wooden houses with decorative window frames and sagging porches.

Our hostess was glad to see us and happy with the present. She made tea and offered vanilla rusks. After our journey, this was delightful! On the wall hung two photographs of two girls who looked very much like their mother. When she noticed me looking at the photos, our hostess said that they were her daughters whom she had lost during the war. Seven years had gone by since the end of the war and she had given up hope of finding them. I was stunned. I recalled the kind hands of this woman on my back, how they were able to lift away the pain, and I wondered whether she thought of her daughters when she worked on me. I felt so sorry for this woman!

Still, when we walked out into the sunshine and once again breathed in the sharp spring air, I felt (a bit guiltily) such a sense of happiness. Here I was with my mother, riding on the tram together, getting home to eat dinner together—not being parted! I was a little bit ashamed of my happiness and desperately wished for this woman's daughters to be found.

Summer, I am eight years old. I've just spent a marvelous vacation in Sochi with my mom and older brother. We're on our way home now, flying out of Odesa. It's one of those Yak-40 commuter trijets, with only thirty-two seats. The last passengers are boarding. Our stewardess seems to be bullying them, rather than inviting them to take their seats. (My mother assures me that our stewardess doesn't like her job and dreams of working for a big airliner.) As we fly, I am bored, with nothing to do, so I decide to walk through the plane. Our stewardess is fast asleep in the last seat near the galley. I'm thirsty—this gives me something to do: I go into the service area, set up little cups on the tray, pour in the lemonade, and start walking down the aisle, offering a drink to each passenger. Everyone is laughing, and they even clap for me—"Look at our little stewardess!" The noise brings the pilot out of the cockpit, but he's smiling. I see amused approval in my mother's eyes. I'm pleased that I found something to do and everyone is smiling. If I'm feeling self-conscious now, I don't show it. Soon we are landing, my daddy is there waiting for us, my whole family back together, and I'm the happiest child in the world.

I am walking down Bolshaya Dmitrovka in the heart of Moscow, where the capital's gorgeous imperial architecture houses some of today's trendiest clubs. It's a Saturday evening. People are partying. Everyone is having a fantastic time. It's warm, it's dark, it's summertime. And then there's me, all by myself. I had gotten out and started to walk, wanting to see Moscow by foot, not from the window of a chauffeured car.

A bicyclist comes up behind me. He can't see my face, so he says to my back, "Hey, want a ride?"

Ah, the boy is having fun. I turn around and say, "Sure, let's go."

Then he sees who he is dealing with: "You're kidding me!"

"You'd be surprised—on a night like this, anything can happen."

"But how will I take someone like you?"

"Well, why did you suggest it?"

So he ends up pedaling standing up, so that I can sit on the seat. I have very long legs—I'll just insert that compliment to myself here—so I had to keep my knees bent. I rode like that, with my legs scrunched up. And he, the poor boy, had to pedal that bike with my sixty-four kilos on it. A warm evening, Indian summer, people all around, this beautiful street, and I am riding, riding with my legs scrunched up, along Bolshaya Dmitrovka. Happiness happened.

*—Irina Khakamada*

Irina Khakamada is one of the most recognizable women in post-Soviet Russia. With a doctorate in economics from Moscow State University, she made her mark in national politics by being repeatedly elected to the State Duma (parliament). She left politics in 2008 to focus on a lucrative career as a business coach, in particular for women. She has written bestsellers, such as *Sex in Politics, The Dao of Life: A Master Class from a Staunch Individualist,* and *In Anticipation of Yourself: From Image to Style.* Fluent in French and English, as well as Russian, Irina Khakamada was nominated for the Nobel Peace Prize in 2005.

The happiness that I have lies outside my window in St. Petersburg. In fact, it *is* St. Petersburg. A city with a very peculiar feature—it gives you a sense of invulnerability. We often associate the feeling of invulnerability with having a lot of money, or with being successful. But St. Petersburg, with its low gray skies, its communal apartments with leaky ceilings, has another mechanism for providing that feeling of being invulnerable. The city embraces you when you are down. You can lick your wounds here, regardless of whether there is any money left in your wallet. Petersburg is a city where people are valued for having some kind of knowledge. It could be your knowledge of the Coptic language, or some other completely useless skill, but skill and knowledge are like that secret spice that makes everything taste better. So in Petersburg, all you have to do is live. You don't have to be rich. You can be beset with various woes, but this city will put an arm of gray drizzle around your shoulders. If things are really bad, you can walk out of your apartment, down to the street below. On the street where I live, there are now about a dozen night clubs, bars, restaurants, even a hookah bar. Most importantly, there is a jazz club, where jam sessions start after 11:00 pm, when musicians have finished playing their restaurant gigs and gather here to play with each other for free. When you go in, you put a few coins down in exchange for a token, and each token gets you a goblet of wine. It seems to me that the meaning of life inheres in this kind of existence, when you are one thread woven into the much larger fabric of the city. When you do not fit in, and do not torture yourself over the fact that you are not the central image in the picture, you are simply one dab, that one dab of color that cannot be taken out of the picture. I'm not sure that this is one hundred percent of happiness, but I am convinced that it is a worthy portion.

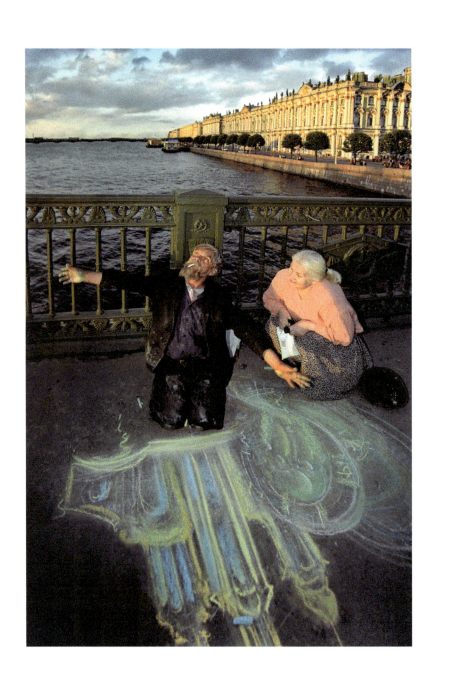

*Richard III*—by the Satiricon Theater company, on tour in our city in 2009. All three hours of the performance were pure happiness. When I walked back out afterwards—honestly, for a moment I didn't know where I was or who I was. Then I got in my car and drove home with the idea that I would immediately buy tickets and fly to Moscow to see the same show again.

Human happiness consists of drinking champagne with the midwives in the building where your child was just born and you were there to assist with his entry into this world. But an actor's happiness can be something else. Like: once, I played Treplev in Chekhov's play *The Seagull*. Instead of my character shooting himself offstage, the director had him commit suicide onstage; that is, he dies in front of the audience. Our entire company, including me, was happy when there was no applause. The last scene … echo of a gunshot … the curtain slowly goes down, it will not come up again … and complete silence.

*— Ivars Kalniņš*

One of the biggest sources of happiness for a parent is watching their children perform. Parents usually cry at their children's performances. And those tears of happiness are for real. So when my daughter, as a very skinny fourteen-year-old, played her Chopin piece with ice-cold little fingers, you bet I sat with tears streaming down my face, especially since the day before we had gone to a flea market and bought her first ever long dress. For my daughter, the whole thing was terrible—it was an exam. But for me it was enormous happiness. Likewise, when my son Gena puts on shows I am incredibly proud and happy. And when our grandson Peter, now twelve years old, was admitted to the music school, and played his violin piece in concert, our entire family was there, crying happily. You start to get the picture? When a child arranges a showing of their drawings, or when they suddenly come up with a dance, our rejoicing is human happiness in its purest form.

*—Lyudmila Petrushevskaya*

> Lyudmila Petrushevskaya (b. 1938) is one of Russia's living literary legends, although she herself has claimed that "Russia is a land of women Homers.… They're

> extraordinarily talented storytellers. I'm just a listener among them." She has written plays, children's tales, gritty novellas, animated films, and (late in life) cabaret lyrics.

*The Adventures of Invisible Worms in Russia, or Gogol-Mogol (Sabayon, Zabaione, Advocaat, Eggnog)*—this is the title of my happiness. It was a performance piece. We threw six thousand eggs onto the stage, along with four tons of garbage. Seventy actors, encased in various art objects, walked onto this stage, stripping off their clothes and throwing them into the audience. What I intended to signify with this show took on its own unexpected momentum, and it turned into improvised chaos, in a way that I would never have been able to predict. I was bowled over by the power of the unanticipated, of pure spontaneity, which happened during *Gogol-Mogol*. The miracle of abruptly revealing that which you had not known before—for an artist this is the highest point of happiness.

—*Andrei Bartenev, designer*

> Gogol-mogol (kogel mogel) is beloved dessert in many parts of Russia, Eastern Europe, and the Caucasus. Its origins may be as a Jewish cure for a sore throat; its enduring popularity may have to do with the simplicity and ubiquity of its ingredients (eggs, sugar or honey, perhaps milk or booze). And, of course, its rhyming name is more fun than that of its Western cousins.

The premiere of my movie *Moscow Doesn't Believe in Tears* was on February 11, 1980, in the Rossiya Theater on Pushkin Square. Afterwards, we went out to celebrate. Batalov was there, and Alentova, Muravyova, Raya Ryazanova … a lot of people, all the members of our film crew. In a way, these celebrations are also a goodbye: the film is out, and now it's time to think about the next one. So this is not the moment of happiness I want to tell you about. That moment came two days later, on February 13.

Back then I lived in the Olympic Village neighborhood, quite a distance from the center of Moscow. Today, I take the metro in to run some errands. At the Tverskaya stop, I go up the escalator and emerge out onto the street, but something strange is going on. All of Pushkin Square is completely jammed with crowds. People all over the place. Are they dispersing a protest of some sort, a rally of dissidents? Or maybe everyone has suddenly caught on that some deficit item is for sale in one of these stores? I'm confused … until I realize that this is the line to see my movie! The movie that consumed my heart and soul to make! Here, in the middle of winter, people are standing in line for five hours to see it!

—*Vladimir Menshov*

*Moscow Doesn't Believe in Tears* won the Academy Award for Best Foreign Film in 1981.

About moments of happiness. There are a lot of them. They happen practically every day. But we don't always notice them. The ones we notice are always associated in some way with music, most likely because music—is love. At least this is the case for me. I remember having doubts: Does anyone really need my songs, am I on the right path? At that point in my life, I was not in the French group Nouvelle Vague, nor did I have gigs in other countries and cities. In fact, it really was not clear whether anybody needed my music or not. I remember shutting myself in my room in St. Petersburg and simply starting to sing, to myself. At that moment I felt happiness, when I realized that *I* need my music, and that my songs *are* necessary, to make *me* happy.

—*Jenia Lubich*

Jenia Lubich is a singer-songwriter who performs and writes in Russian, Spanish, English. and French. http://en.jenialubich.com/.

July 2002. We are on our way to the dacha. Our trunk is full of provisions. The company is good. Someone brought a watermelon and somebody brought some real Georgian grappa.

We are all on the same page in the way we think about things, we are all friends. And next to me, *she* is sleeping. Things are just beginning with us. The horizon is cloudless. We think it will remain so forever.

I'm a young doctor at the end of the mad nineties, working in a psychiatric hospital near the intensely blue sea of Sevastopol. I'm on night duty. When patients are brought in, I work up a case description and transfer them to the correct division. In addition, I am the one who verifies the condition of drunk drivers brought in by officers of department of vehicle safety, which is the Ukrainian version of our traffic police. For traffic cops, a driver under the influence is money in the pocket. The breathalyzer that turns green when you blow into it—it's like magic. However, there are also some objective metrics to determine a driver's condition, such as blood pressure, coordination tests, etc. Whether or not somebody is legally drunk is decided by a doctor, that is, by me. In those days we didn't draw blood for analysis unless the patient showed symptoms of alcoholic withdrawal. This time, they brought in a young man who was clearly sober. The most valiant warrior in the battle against drunk driving, as I recall, was Sergeant Patsiuk. Patsiuk wanted very badly for me to confirm the young man's "alcoholic intoxication." An hour of negotiations, persuasion, arguments, and barely veiled threats. The whole thing smelled of a suspension of the young man's license, a "plea bargain" to reverse the decision, and a sum of one thousand dollars to appear in Patsiuk's pocket.

But my verdict is firm: "The driver is sober." The cops, silent and sulking like wolves, leave with nothing. The relieved patient and his father leave as well.

The doors close. It's 4:00 am. The hospital is quiet. I am alone on duty. I am filled with a sense of my own righteousness, strength, and Jedi-like enlightenment. My happiness is interrupted by a rap on the window. It's the driver and his father, bringing me a package of sausage and cheese in gratitude.

—*Maksim Kucherenko*

Along with fellow medical student Vladimir Tkachenko, Maksim Kucherenko founded the indie-rock group Undervud. https://www.undervud.ru/.

I am the very happy child of very happy parents. If I compare myself to my peers, or indeed to people older or younger than myself, I understand that I had an amazing childhood. I owe much of this to my parents, because my mother is an absolute lover of life, and my father had a great sense of humor. He taught me so much, most of all a love of music. It's my dad who brought me Bjork—"Not exactly my thing, but you'll like it." He copied cassette tapes of Alanis Morissette for me.

Last summer my father passed away. But I can't say that I'm devastated. I know exactly that Dad would be unhappy to find me excessively grieving. All the more so because the connection between us hasn't been broken. I know he's somewhere right nearby, and that he is keeping me safe.

Once when I was on tour, they put us in a hotel right next to a racetrack. A huge racing event was supposed to begin there on the following day. I remember the evening. I was miserable. I missed my father so badly, to my bones. I even started feeling sorry for myself.

This is a story about magic. About half an hour after I had started to nap, they began to do a soundcheck at the racetrack. But not just any soundcheck! They blasted Dad's favorite song over the loudspeakers. I have never received such a fat hint from anyone in my life. Okay, Dad, I get it. You're okay, I'm okay; I miss you, but I am not sad! That was a moment of magic.

—*Yolka*

> Yolka [which means "Christmas tree"] is the stage name (and childhood nickname) of a Ukrainian-born Russian pop star and *power vocalist*. She started out in jazz, soul, and rap, but achieved her first big hit with the pop song "Provence" in 2010, which imagines a "Burgundy horizon and burgundy Bordeaux in a wine glass / Already so close *to being there,* I can't believe it. ..."

1999, summer, in the Polish town of Kalisz, the biennial street theater festival. On Sunday, the central square is packed with people. There are only three of us. Getting ready for the performance, I literally have to use my hands to put my two co-performers, who are paralyzed with stage fright, into place. We are supposed to stand on a stepped pyramid of blocks. When our act is announced, the audience makes noise, somebody whistles loudly. We begin with an

old Haitian folksong, singing a cappella with a bass drum. After one measure, the entire square is completely hushed. We start to descend, our long capes swirling behind us in complicated patterns. … And at that moment there is no more separation: no "I" or "we" or "they"—only one communal *com-position*, a miracle.

August 2004. I am DJing at the legendary Casablanca in New York. They called me in to DJ in the upstairs restaurant, where there's a bar and small tables. The main DJ is playing downstairs, where the dance floor is. It's already past midnight. Almost nobody is sitting at the tables; everyone is crowded around the bar. The girls are starting to dance in place. I put on one incendiary tune after another, even though there is no dance floor and in theory I am supposed to be playing soft evening music. One group of young people shoves a few tables to the side and is already burning up the little spot they've just made available. I smile. I love it when people dance—that's what the DJ is for! More and more people are coming upstairs, so I keep turning up the volume. "Nobody is downstairs anymore, everyone is *here*!" one of my friends yells out to me. They are dancing by themselves and with each other, arms stretching out from the soul. More and more are coming in. I signal to the barman to dim the lights. By now all the tables have been moved to the sides and I have a real club event! I look for the next song, flipping through a stack of records, and realize that at this moment I am simply happy. Right now, at this moment. Happy because everyone is dancing when nobody expected to. Happy that I have this work and music unites us all. The startled barmen can hardly mix cocktails fast enough. Everyone is singing the refrain of a hit song in unison. Eyes are blazing. The energy in the room is over the top. I have the sensation of myself as a savior of humankind.

*—Alex*

For some reason I remember this moment very clearly. Vilnius, the capital of Lithuania, where I grew up. I am seven years old. I am walking along the street that leads from my house to the theater. It's only a short distance. It's also a beautiful part of the old town, all cobblestoned, with houses lined by history, and the constant aroma of baked goods and coffee—a drink for grown-ups only. As I'm walking, I see a bunch of kids joyfully sledding down a little hill. I stop and watch them. As I watch them, I think to myself, "Those kids have no idea how happy I am;

because even though they get to go sledding, I get to go act in play, and that is true happiness." Of course, this is a rather peculiar thought process for a child. But it's all true.

*—Ingeborga Dapkunaite*

> Ingeborga Dapkunaite is a Lithuanian, Russian, and British citizen, known in the West for her roles in *Mission Impossible* (1996), *Seven Years in Tibet* (1997)—in which she played Brad Pitt's wife—and *Hannibal Rising* (2007). She has starred in numerous acclaimed Russian films and TV series, and most recently was the Russian diplomat Irina Sidorova in Netflix's Norwegian eco-thriller *Okkupert* (2015–20).

This happened in the previous century, in the mid-seventies. My husband is the senior Soviet hydrologist stationed in Cuba. We live with our children in Havana, in a nice family hotel called Sierra Maestro, which is located right on the Gulf of Mexico. One day, having awakened early, I walked out onto our balcony and saw a light fog hovering over the water, and in the middle of the harbor, at anchor, the sailboat *Tovarishch* rose through the mist. It looked as though the boat was sailing through the air. The water was invisible in the fog. Behind me, the sun was just rising behind our twelve-story hotel, coloring the sails a deep pink. It's hard to convey how ecstatic I felt, as if I could run to that fairy-tale boat with the scarlet sails right now and ask for my secret wish to be granted.

I was thirty-five years old at the time, and we had a wonderful family with two children, a son and a daughter. What kind of happiness was I still searching for, when my soul leapt towards those scarlet sails? I don't know. Forgive me this ecstatic tone. I am seventy-five years old now. My husband is already long gone, but thanks to him I was able to experience that thrill of joy. One doesn't forget moments like that. It was certainly not the only moment of happiness in my life, but for some reason it's the one I wanted to tell you about.

> In the romantic fantasy *Scarlet Sails* (1922) by Alexander Grin, the prince makes the poor girl's dreams come true. The story's motif is celebrated in St. Petersburg to this day in a spectacular parade of sailboats down the Neva River at the height of the White Nights period in late June.

Winter 2005, in February. This has been the coldest winter I've ever experienced, twenty-five degrees [Celsius] below zero instead of the usual minus ten. I am in the ninth grade and recently I got to know some older guys, about three to five years older, who play guitar. I am so captivated by the world of rock music, I've decided to buy myself a bass guitar. The next morning, I grab my recently purchased smartphone—a Nokia 3230, red like a brick—and stick the headphones into my ears; I put on my light running shoes, because wearing winter boots would slow down my movements and look stupid, and I head off for the center of town to check out the music stores. Within ten minutes I can't even feel my frozen toes, but who cares?; and I'm admiring the snow-laden trees, and how the little river that flows through our town has turned to ice.

I go into each store, pick up the bass guitars, feel them, smell the aroma of the varnish, thumb through the catalogs. I myself do not know how to play, but I ask the salesperson to plug in the absurdly expensive (by my standards at the time) bass with a price tag of three hundred dollars. He connects it to an amp and fiddles with the knobs for a few minutes to adjust the tone. The dark semi-basement of the store fills with the sound of an unhurried bass riff, a sound that is both solid and velvety, every so often punctuated by a harsh metallic note. This truly masculine sound, which resonates with strength and romance, agitates every string in my soul.

At the time, I didn't know that within a week I would trade in my phone for the cheapest bass guitar, and that within a month there would be serious problems and I'd have to break off contact with the older guys; and that six months later I would sell my instrument, having never really learned how to play.

I've often told myself that happiness is the journey, the process, the movement towards something. And not the result.

My story is about a sad kind of happiness, which happened to me thirteen years ago. I was lying with my newborn son in the neurology ward. I had made friends with many of the

other mothers in the ward, all of whom had their own worries. One night, having put our little ones to sleep, we gathered together in the ward cafeteria, pushed together the tables, and pretended we were at a feast. You wouldn't believe what came out! We joked, we roared with laughter, we talked about fashion and husbands. For a few hours, we forgot about our fears. From the outside, you would have thought that these women are completely fine—it would not have occurred to anybody that each one of us was carrying an almost impossibly heavy burden. We stayed together until late at night and, oddly enough, for once not one of our little ones woke up; everything and everyone conspired to give us this time to relax, to forget, to gather new strength. When we had laughed ourselves out, we each went back to our cots. I stood by my little son's crib, the moon shone in through the unblinded window onto his sleeping face. That one night of fun could not cure anything, but as I gazed at my son I felt such warmth and such joy—he is alive, he is with me, we'll figure out how to move forward.

Despite the dire prognosis my son was given at birth, he is now healthy and whole, so every one of his days is also my happiness, our victory.

*—Natalia*

My mother heard this story from her father: "Happiness?" My father's bunkmate from the Belomor hard labor camp repeated the question. "Happiness is: I am home. Next to the stove, crackling with heat, my wife sits in a cherry-red velvet dress, and it smells of frost-dried sheets which have just been brought inside."

I was serving in the army and supposed to be getting out soon. To be honest, I was not serving on the front lines, I mostly sketched things at army headquarters. However, I got my last detail just before being discharged. They always throw some "makeup work" at you before demobilization.

I go to unit headquarters, where an officer is signing my orders. He says, "I'm going to do something nice for you, you've done so much for our unit, so many drawings!"

I say, "Aw, shucks, sir, it's not necessary. …"

But he says, "No, really, I'm going to give you an honorary rank."

I was a confirmed private—ideologically committed to serving out my time without earning any stripes. So I say: "I really don't need a rank."

He says: "Your mother will be so proud." He writes on my discharge ticket: "Lance Sergeant."

Off I go with my paper, knowing that this evening I will be getting on the train to go home. Go is an understatement—I am flying on little wings of joy. And coming right towards me is one of the ensigns. Not any ensign, but the most belligerent, cruel, malicious ensign in our entire unit—a big warrior for his own truth, who has chewed out every single one us at some point.

He stops me. "What's up, Grymov?" he says. "You demobilized or something?"

"Yes, sir, that's exactly right, sir."

"Can I see your discharge ticket?"

I hand it over; please, have a look. The ensign unfolds my ticket and sees that I became a Lance Sergeant—without any orders from above, outside of normal procedures. What a great excuse to give the officers hell!

He triumphantly confiscates my ticket, stuffs it in his breast pocket, and says, "You're not going anywhere, soldier."

That's it. I plunge into an abyss, all my happiness ruined in a single moment. I had already imagined to myself a hundred times how I would be sitting on the train, drinking hot tea with lemon, gazing out the window … or maybe just sleeping until I can't sleep anymore. And now—this.

I look at him. He looks at me. His fat, satisfied face. In that instant, I was in such a state, I was capable of almost anything. But this is what I do (I swear, it just came out of me, I never would have done this before): I put my hand over my heart, look him right in the eyes, and pronounce very clearly: "Comrade Ensign, you are such a *fuck*."

He looks at me, hands back my papers, and says, "Go."

Then he turned around and walked off.

At that moment, I felt a sharp stab of happiness. I had told that man what the everyone in the entire unit wanted to tell him. And then I went home.

*—Yuri Grymov*

> Yuri Grymov (b. 1965) is a Russian cinematographer, director, and producer.

Happiness cannot be classified, but here's what I know:

Happiness is when a big red suitcase stands in the middle of the room, and ahead lies—a journey.

Happiness is not sleeping on a summer evening until five in the morning, still talking to friends on the balcony at dawn.

Happiness is a book or a film that seems … as if it's about me.

Happiness is when I am struck with a genius idea, like recently: the door to the bathroom should be a blackboard to write on with chalk.

Happiness is when my dog is genuinely glad to see me for no reason, and hugs close to me when it's cold.

Happiness is waking up simultaneously on a Sunday morning, looking into each other's sleepy eyes, and getting up to make coffee.

Happiness—is reading about someone else's happiness. I never thought I could cry on a Monday at 4:30 in the afternoon. From happiness.

It turns out that there has been so much happiness in my life, I can't even pick one particular moment. Thank you for making me aware of this!

*—Masha*